pat steir & ugo rondinone

waterfalls & clouds

gravity x time

barry schwabsky

When considering sculpture, I always remember Marguerite Yourcenar's beautiful little essay on its inescapable mutability—or perhaps I should admit that what I think of most is simply its title, which she borrowed from a poem by Victor Hugo: "That Mighty Sculptor, Time". But while time never ceases to modify the statuary made by human hands, in the case of what are known in China as Gongshi or scholar's rocks, time (through the random effects of erosion) may be the sole author. One might be tempted to see a certain irony in Ugo Rondinone's effort to represent these fascinating little objects in their full dimensionality on a monumental scale— a technical feat that leaves nothing to chance or the long rhythms of nature—but there's much more to it than that.

Here, Rondinone exhibits the final three of a group of 20 sculptures, each named after one word from a self-written poem of 20 words: *we run through a desert on burning feet, all of us are glowing our golden faces look twisted and shiny*.; these are *faces, look*, and *twisted*. Conceived in 2008, these were the first of Rondinone's works to employ stone among their materials; they foreshadow in that sense the stone figures and columnar "mountains" he would later construct. With their gray surfaces of pebble-studded concrete, these sculptures don't pretend to reproduce the stones on which they are based. The artist calls these expansive, sinuous, unstable forms "clouds," and their contin-

uously metamorphizing shapes earn the name. Yet I myself would rather speak of smoke, of those puffs of gray that linger in the air above a smoker's head and twirl as unpredictably as his slowly revolving thoughts—*Toute l'âme résumée | … | Dans plusieurs ronds de fumée | Abolis en autres ronds*, as Stéphane Mallarmé wrote: "The whole soul summed up in so many rings of smoke that lose themselves in other rings." Indeed, the form of these sculptures is absolute fluidity, like the water that is time's main sculpting tool in the making of scholar's rocks. Even scaled up to two or three times human height, they're too involved in flowing in and around and out of themselves to care who's looking; they don't dominate the viewer. But neither do they let themselves be easily known. Not only are they filled with unexpected nooks and crannies, but their appearance from any one side reveals nothing about how they will look from another vantage point. The more attentive the viewer, paradoxically, the more likely it may be that he or she will become so entranced by the individual details of the sculptures' constantly mutating form as to lose track of the whole. One finds oneself circling and circling them, not even quite sure at first whether one has come back to where one started—because everything constantly looks different, reveals ever-unfamiliar aspects. And then there's the pareidolia: these abstract forms are full of faces. Don't you experience your gaze being caught by other, uncanny

gazes as the many apertures in the sculptures' forms transmute into eyes that question you just as intently as you examine them? In the unending process of perception, is the perceiver ultimately the one who's perceived?

If Rondinone's homage is to that mighty sculptor time, one might well adapt Yourcenar and Hugo's phrasing to say that Pat Steir puts her faith in that virtuoso painter gravity. Accepting Rondinone's invitation to exhibit together, she has made a group of new paintings that match his scholar's rock sculptures in scale—each canvas is more than three meters tall—and, just as important, in inspiration. Steir, too, finds a stimulus in the arts of China. As she once explained to *The Brooklyn Rail* publisher Phong Bui, it was "looking at Chinese Literati paintings and at Southern Song Dynasty pottery and painting" that convinced her that she could "use nature to paint a picture of itself by pouring the paint. That gravity would paint my painting with me." Here is where we find the piquant contrast between these two juxtaposed bodies of work: in these sculptures, Rondinone has not harnessed the action of nature but represented its effects, using the artifice of technique to make those effects more perspicuous and, as it were, physically involving, while Steir has drafted nature as her collaborator. Steir speaks of John Cage as a major source of inspiration, along with Agnes

Martin, Sol LeWitt, Robert Ryman, and the practice of meditation. Understanding that Cage used the *I Ching* to create a kind of nature-like chaos, and inspired by his daring and poetry, Steir developed her practice of employing nature, so to speak, as her studio assistant. By putting down her paint in a very emphatic, even willful way and then letting gravity take the paint where it should go—using this fundamental force to interpret and extend the consequence of her gesture on a scale beyond her own physical capacity—she gives color a monumental impact. In these *Flags for Ugo*, it's not a question so much of *seeing* the various hues as of *experiencing* them: the effect is that physical.

And yet, the paintings are full of subtlety, of nuance. The grounds may be nocturnal in tone, but far from colorless, they are chromatically rich enough to have been finished paintings in themselves. The brighter hues (or white), like columns at the center of each canvas, may seem to assert themselves as figures before those grounds, but notice how, as each color dissipates itself in traveling down the length of the rectangle, it seems to rejoin the ground as one more tinge or nuance in its complex amalgam of tones. A dichotomy is posited and then overcome.

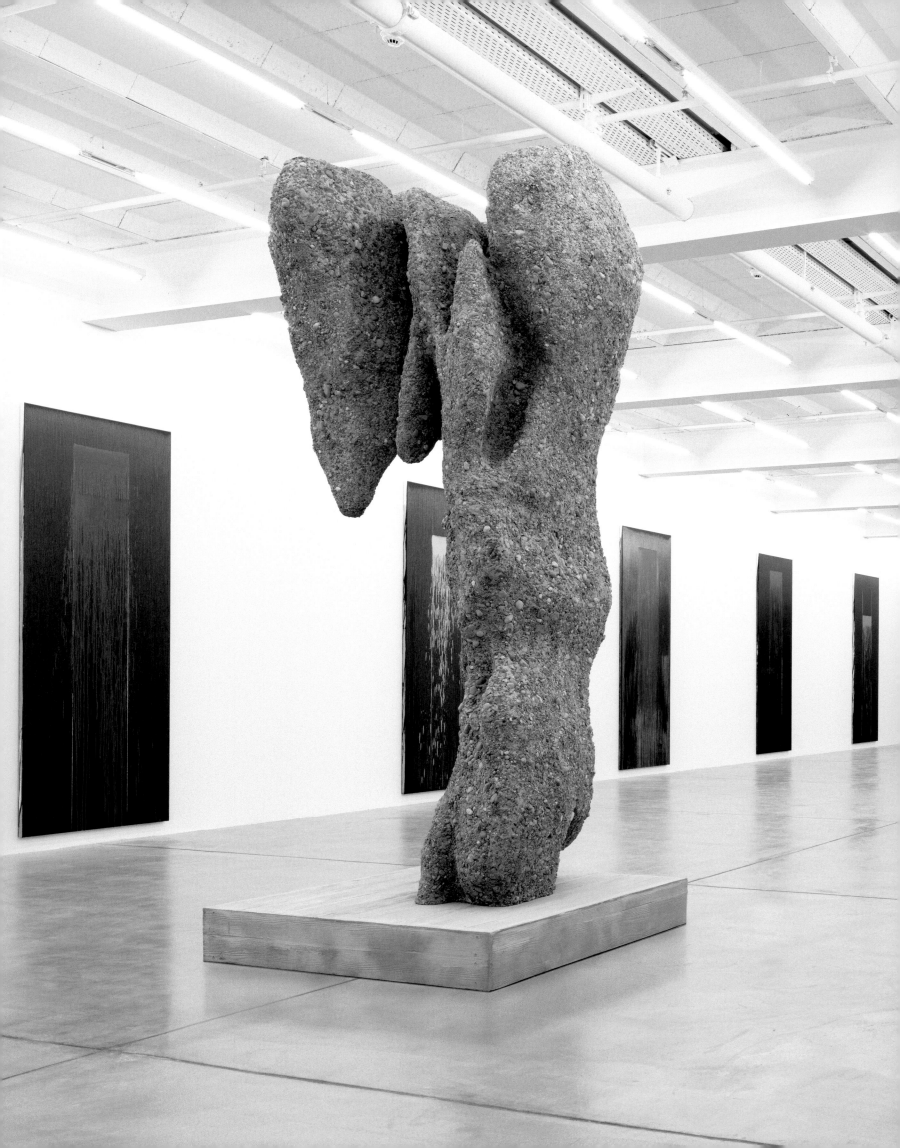

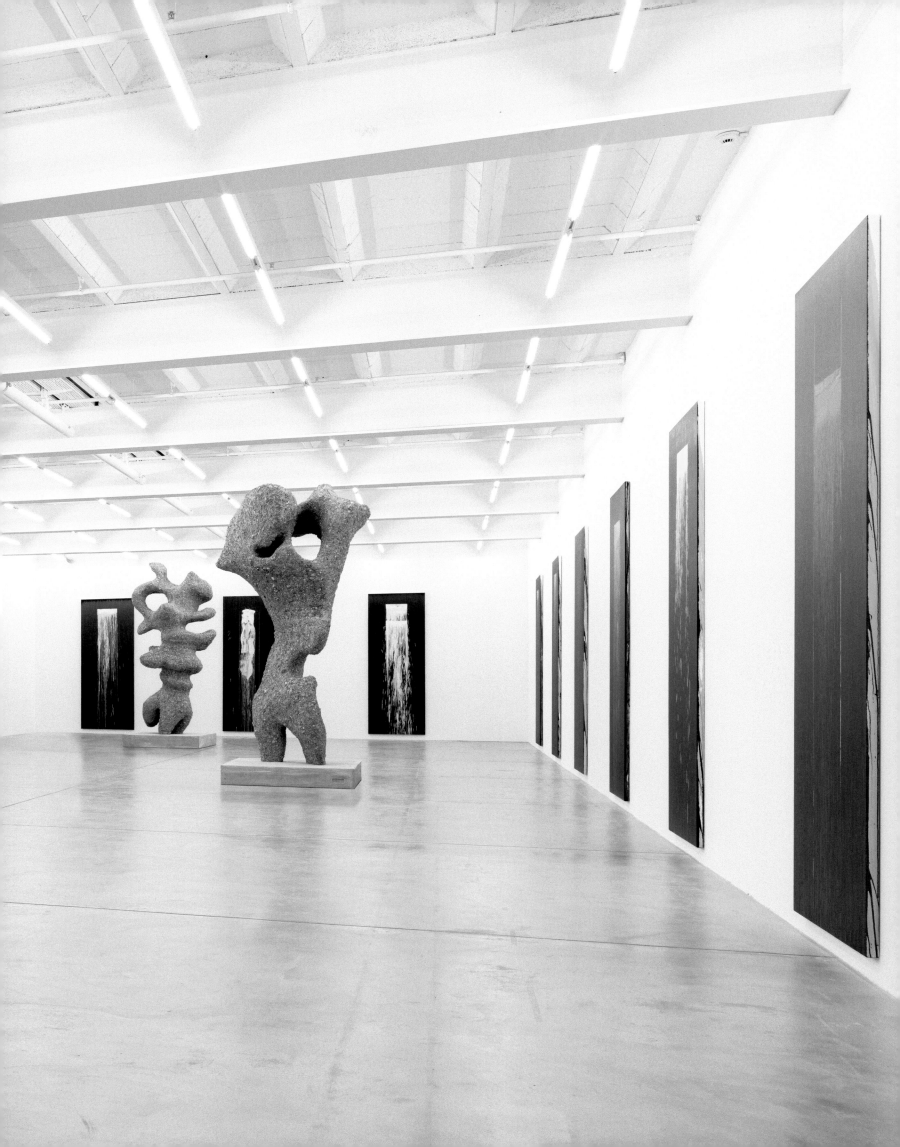

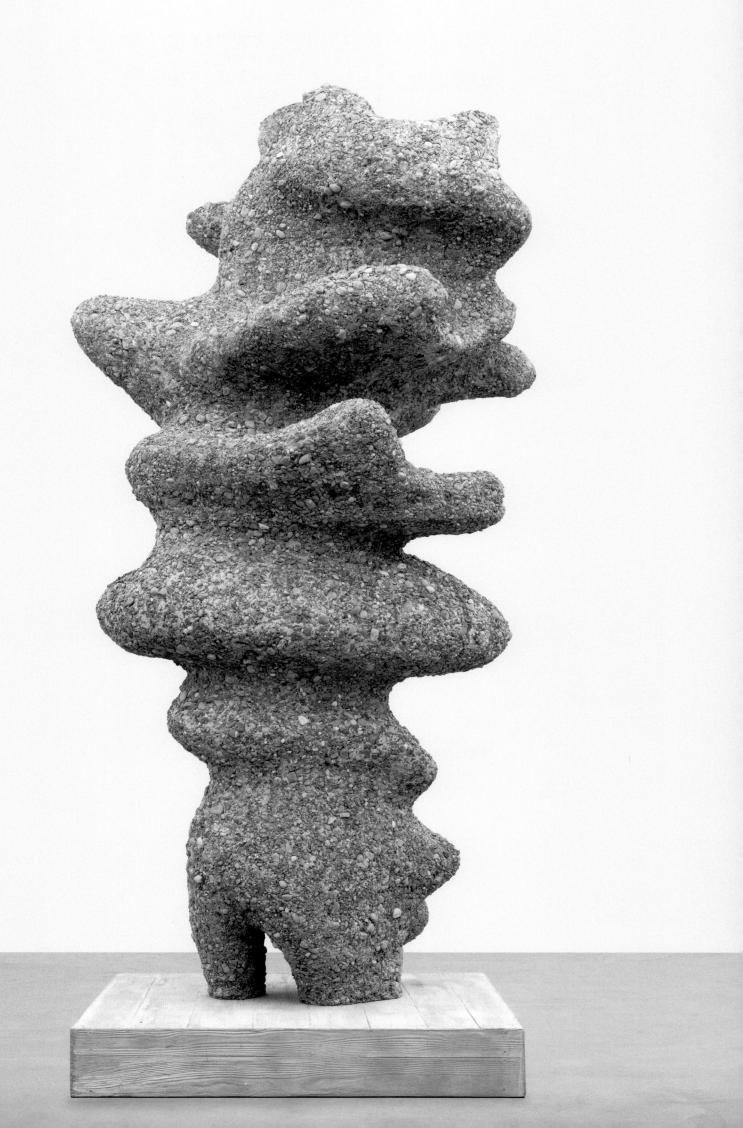

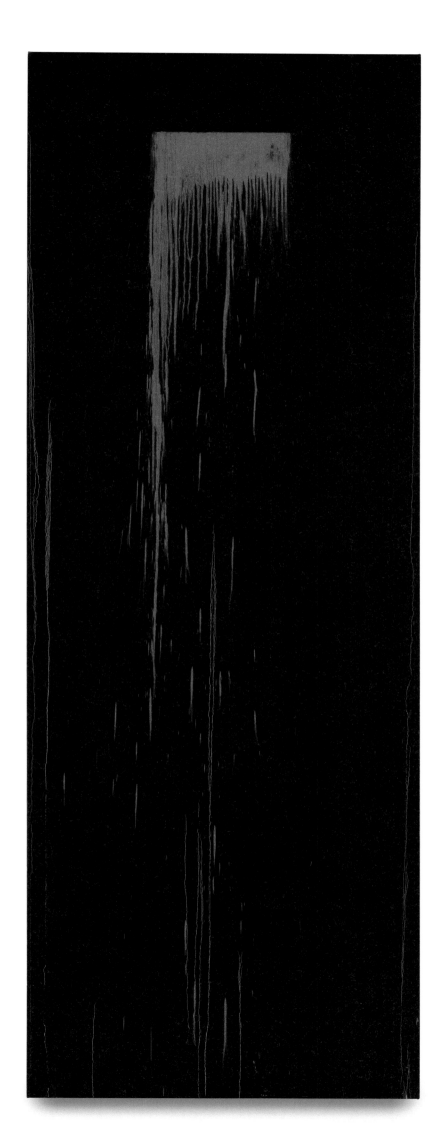

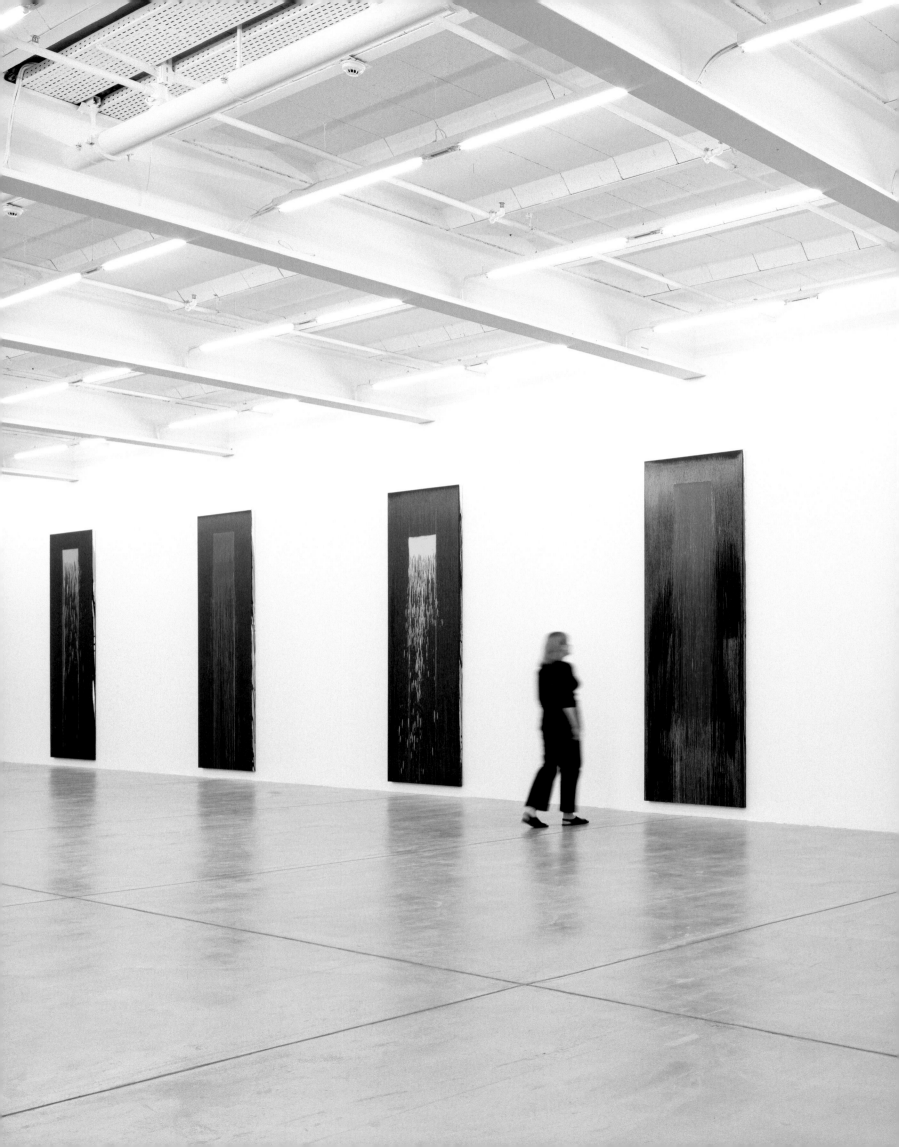

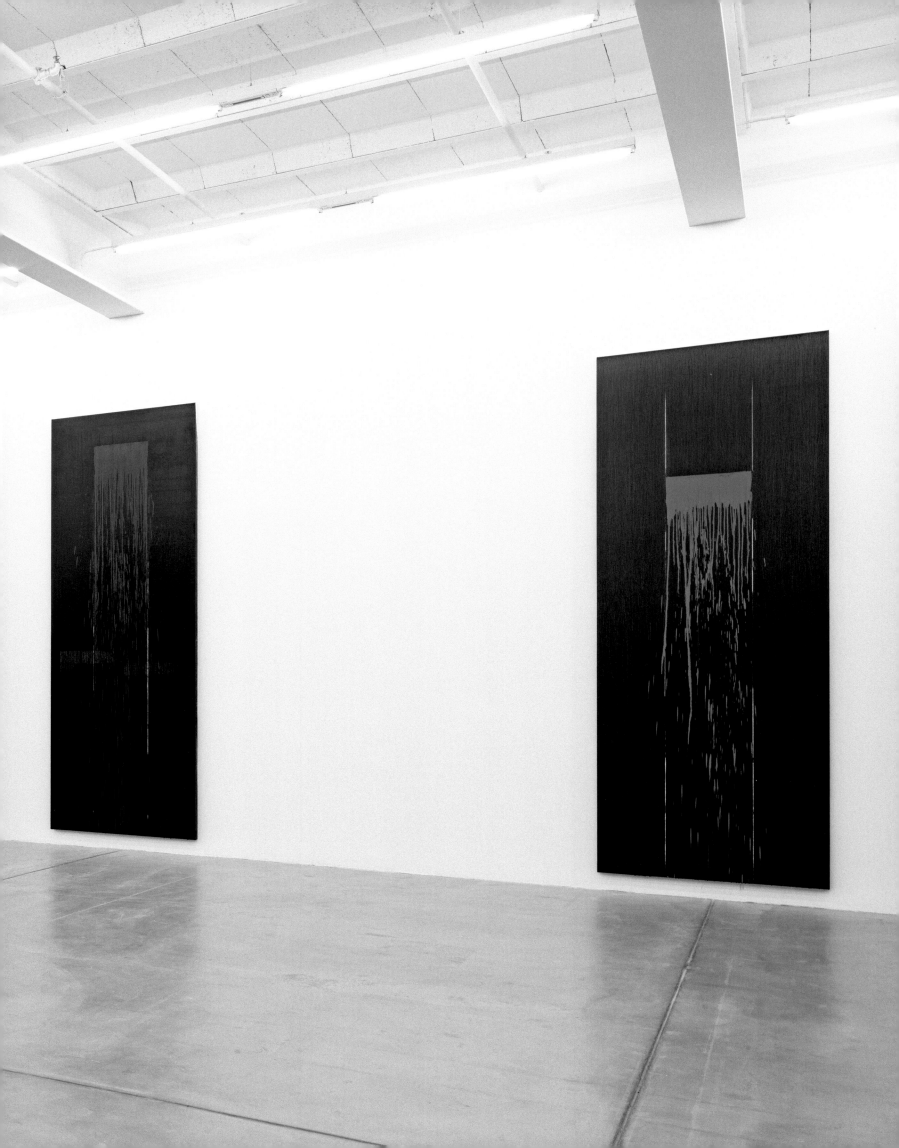

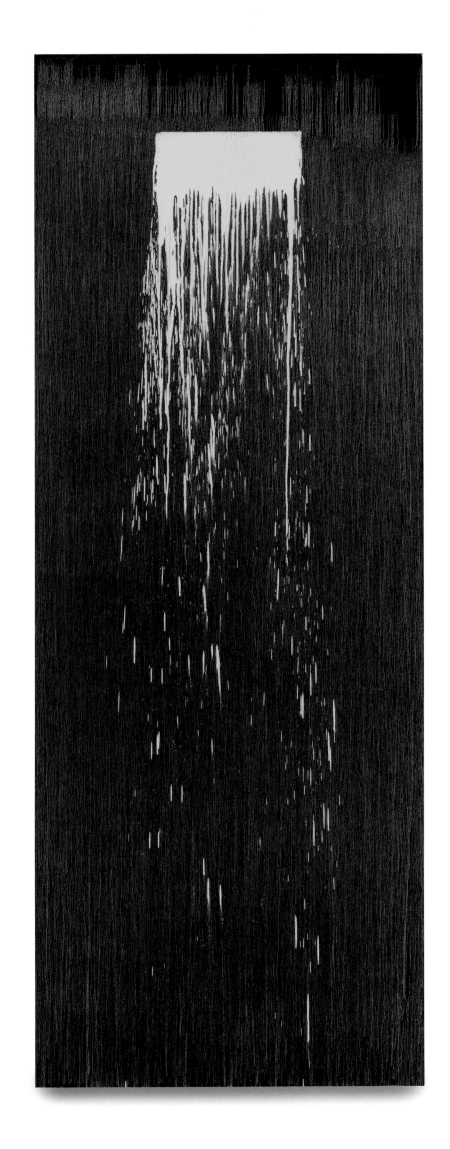

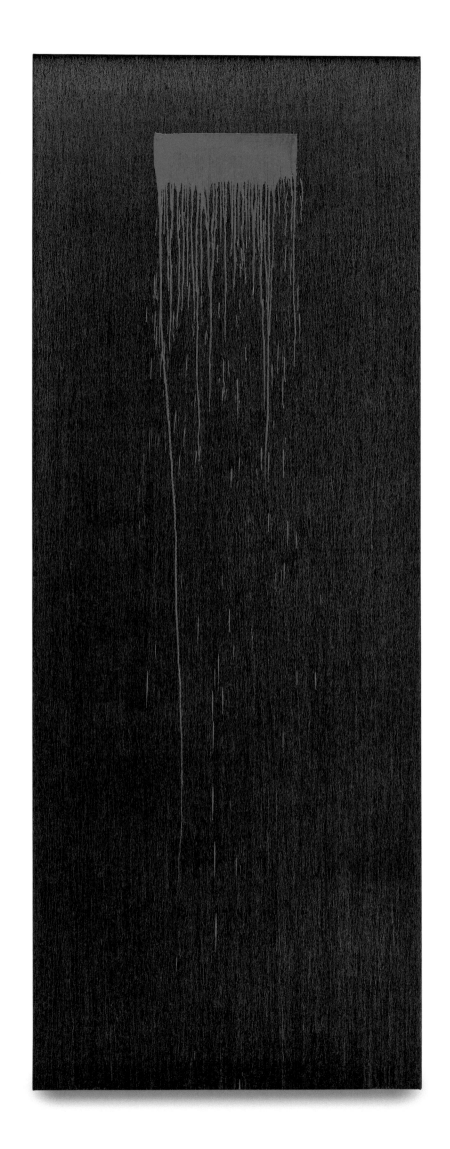

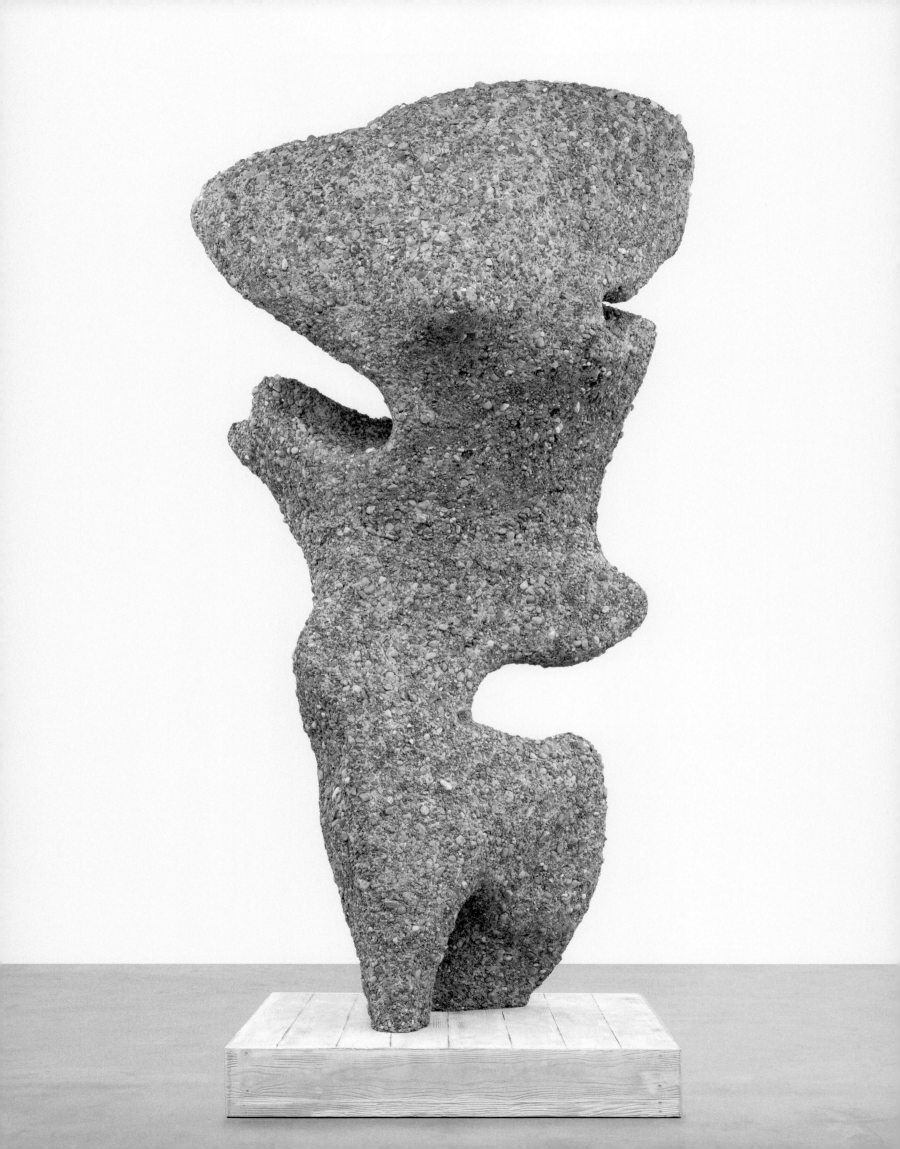

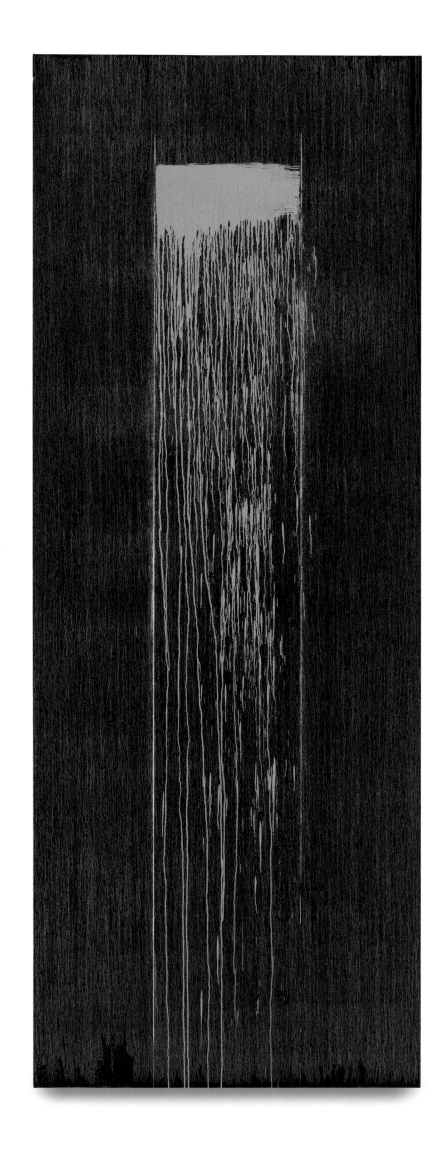

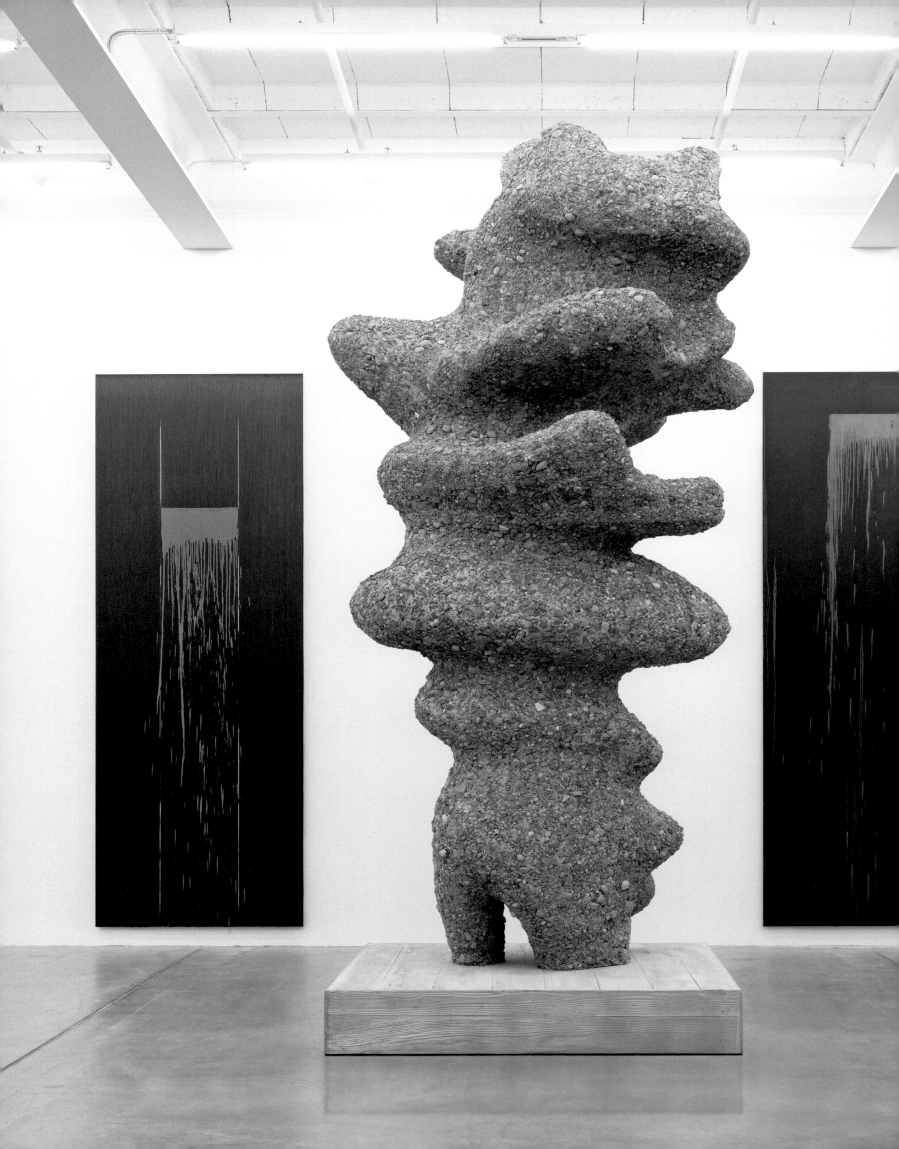

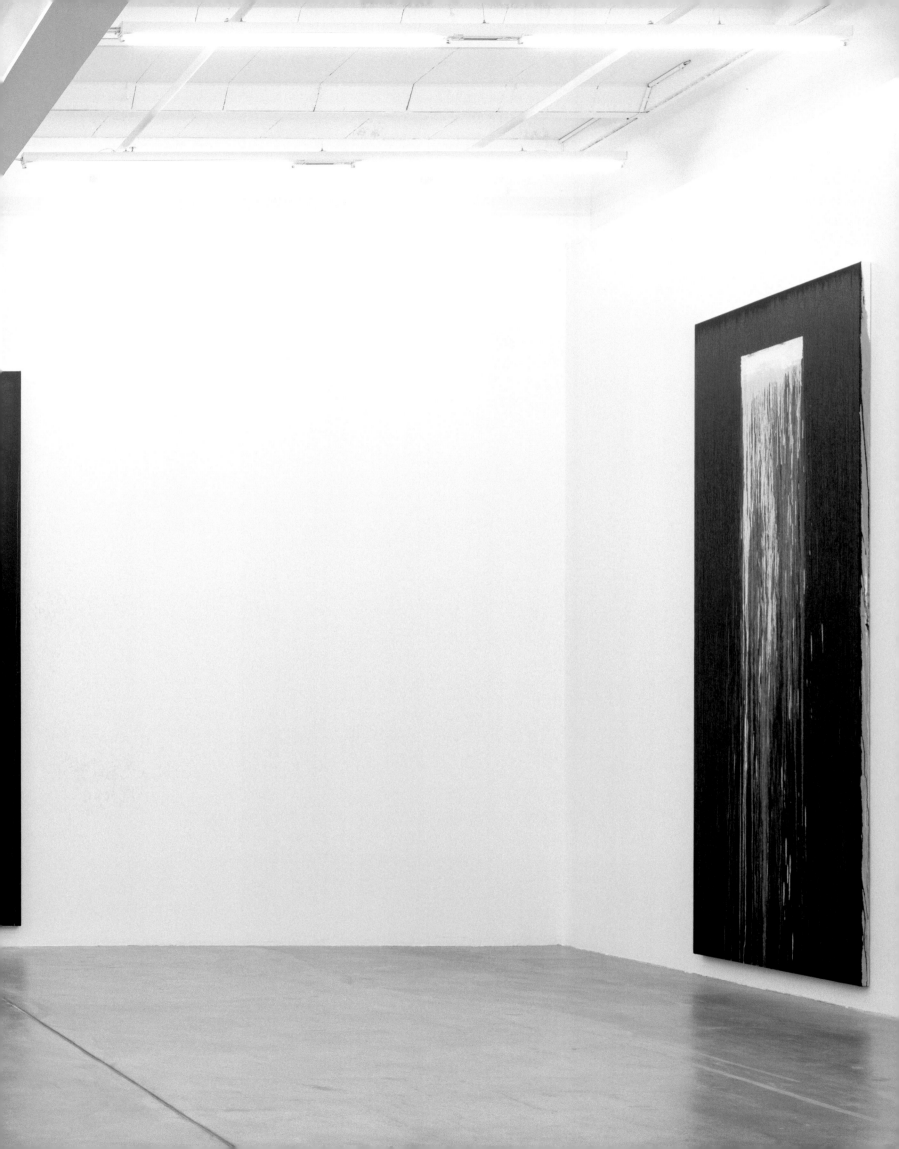

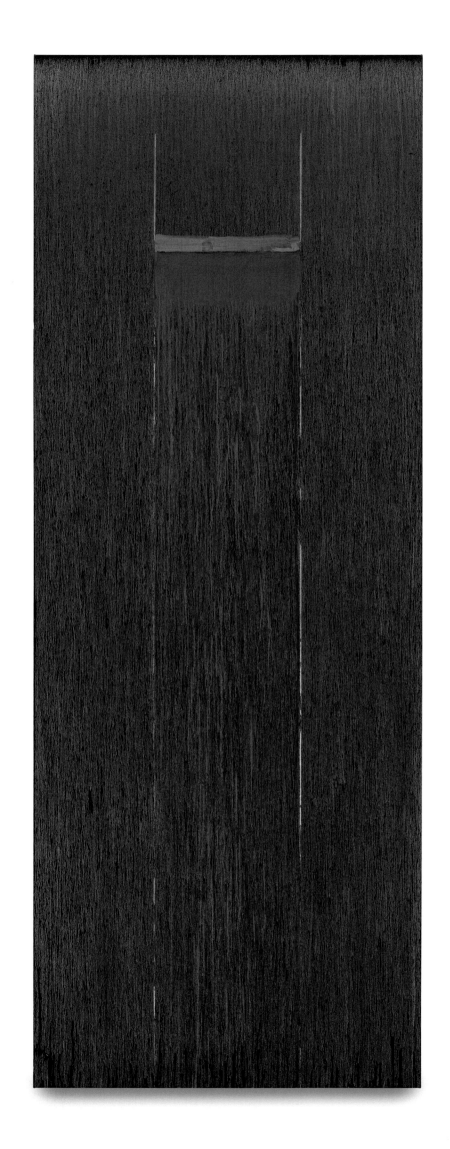

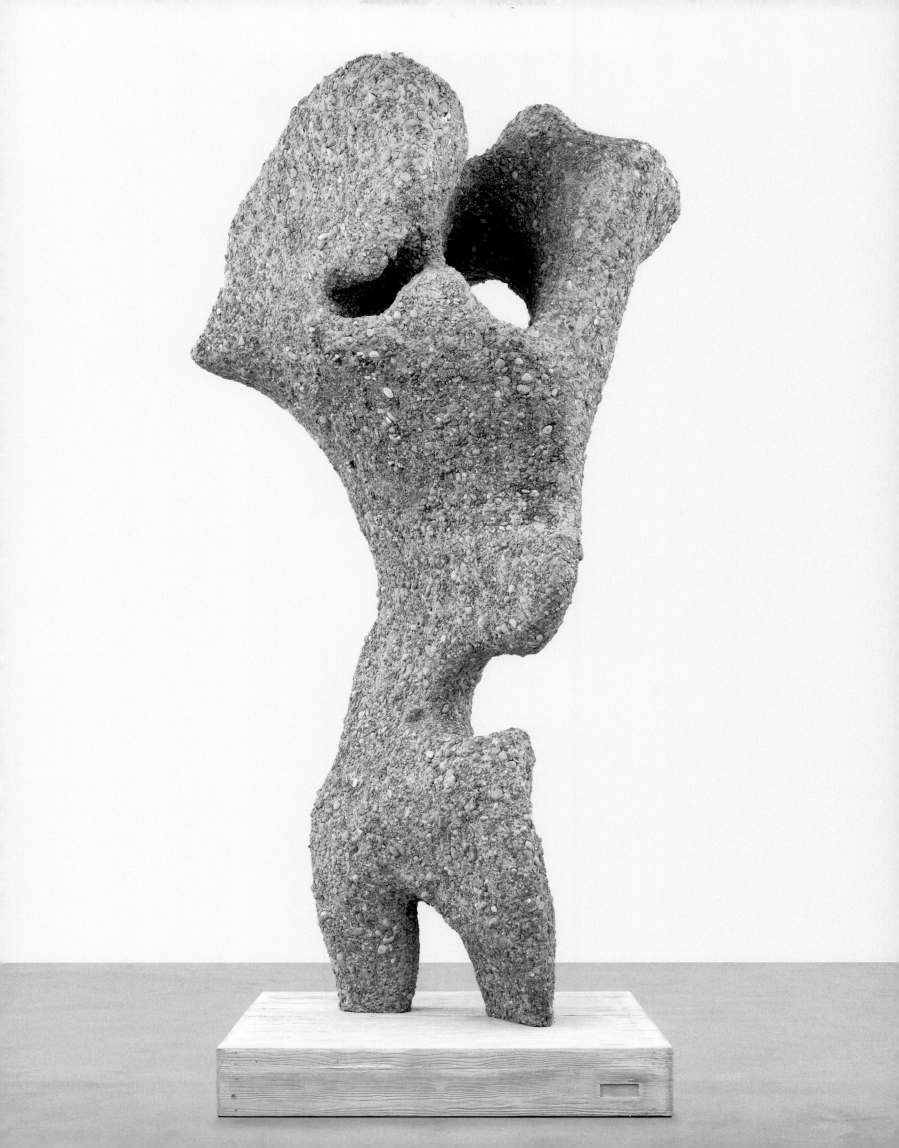

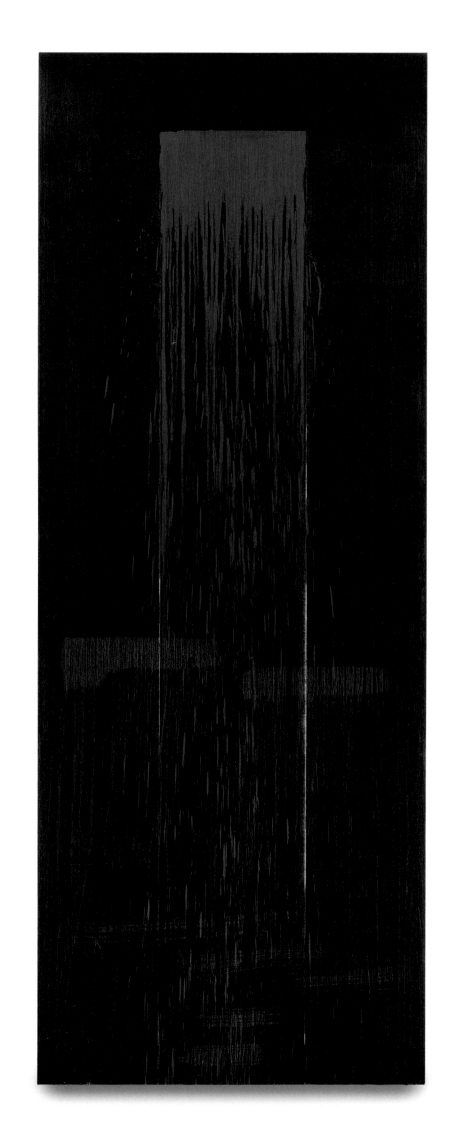

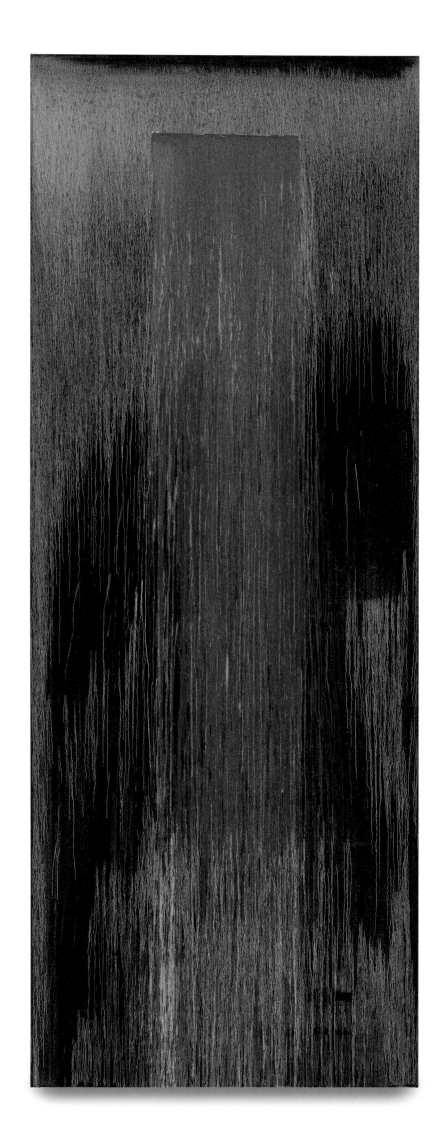

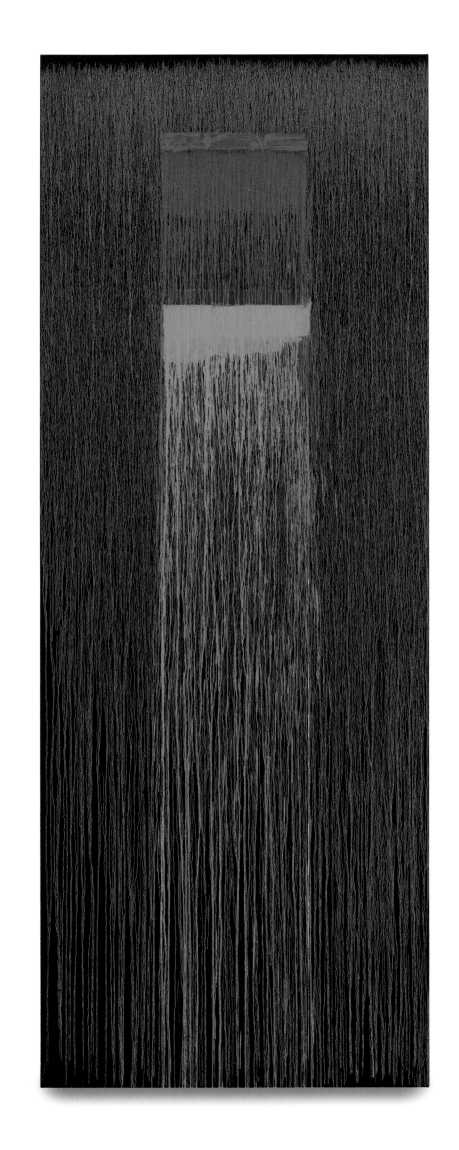

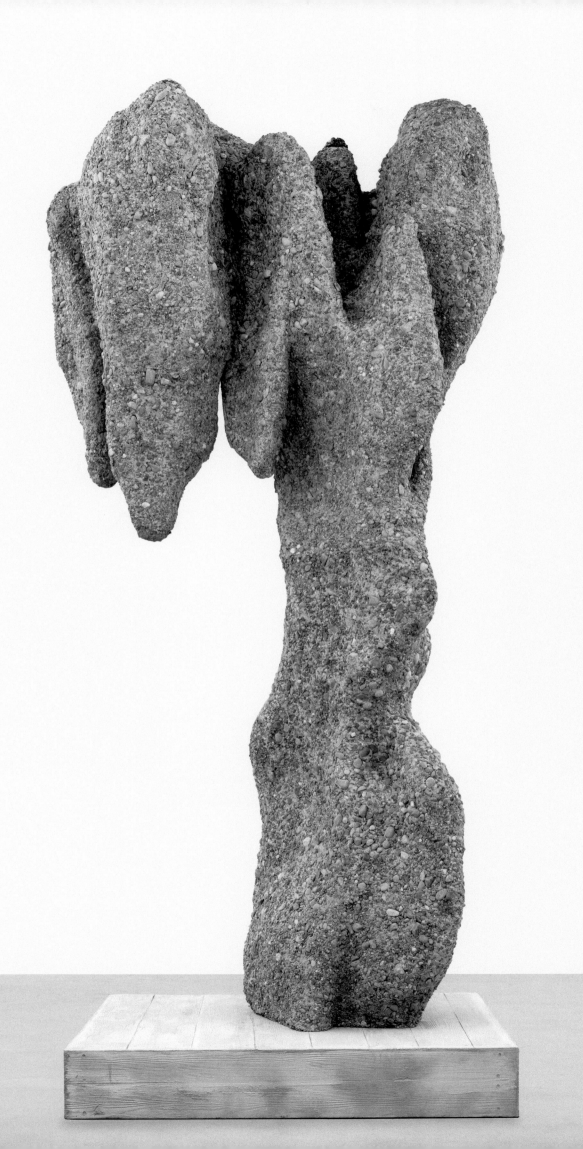

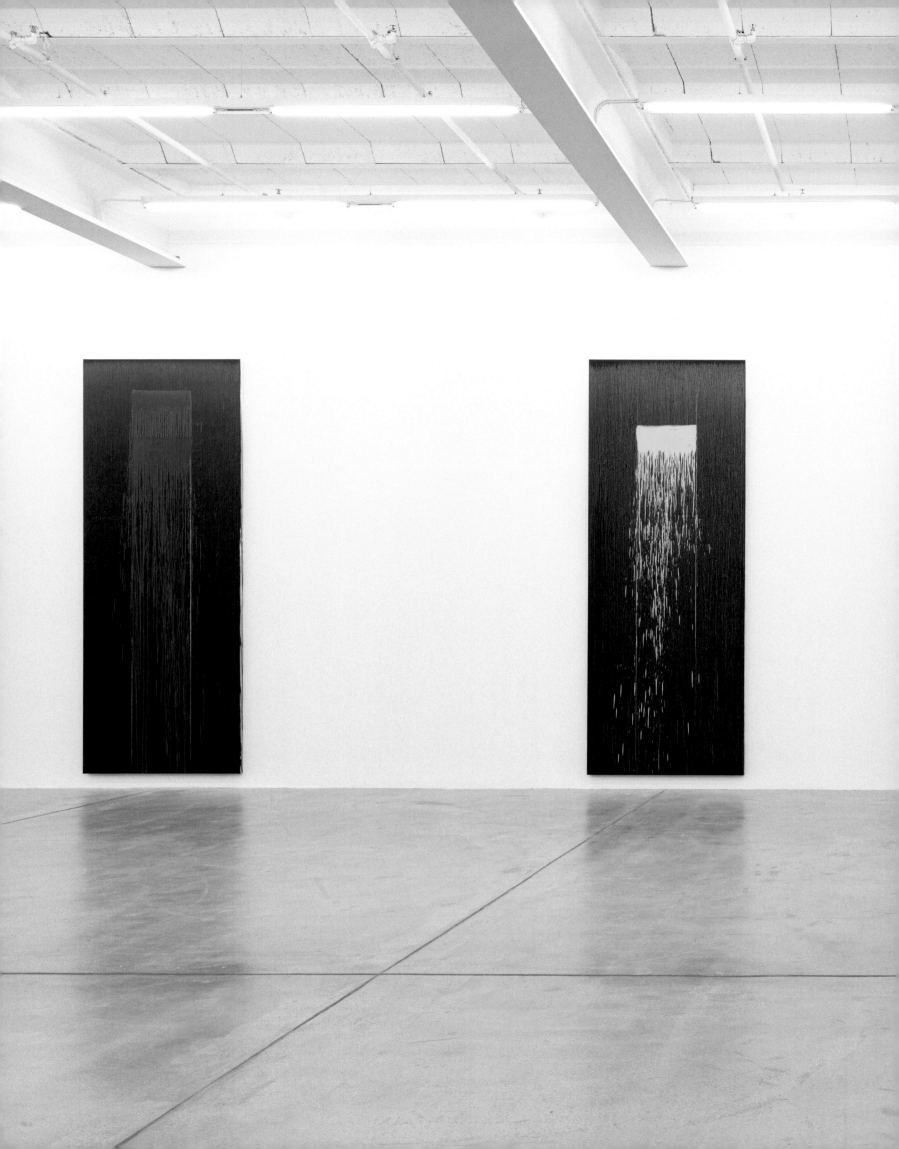

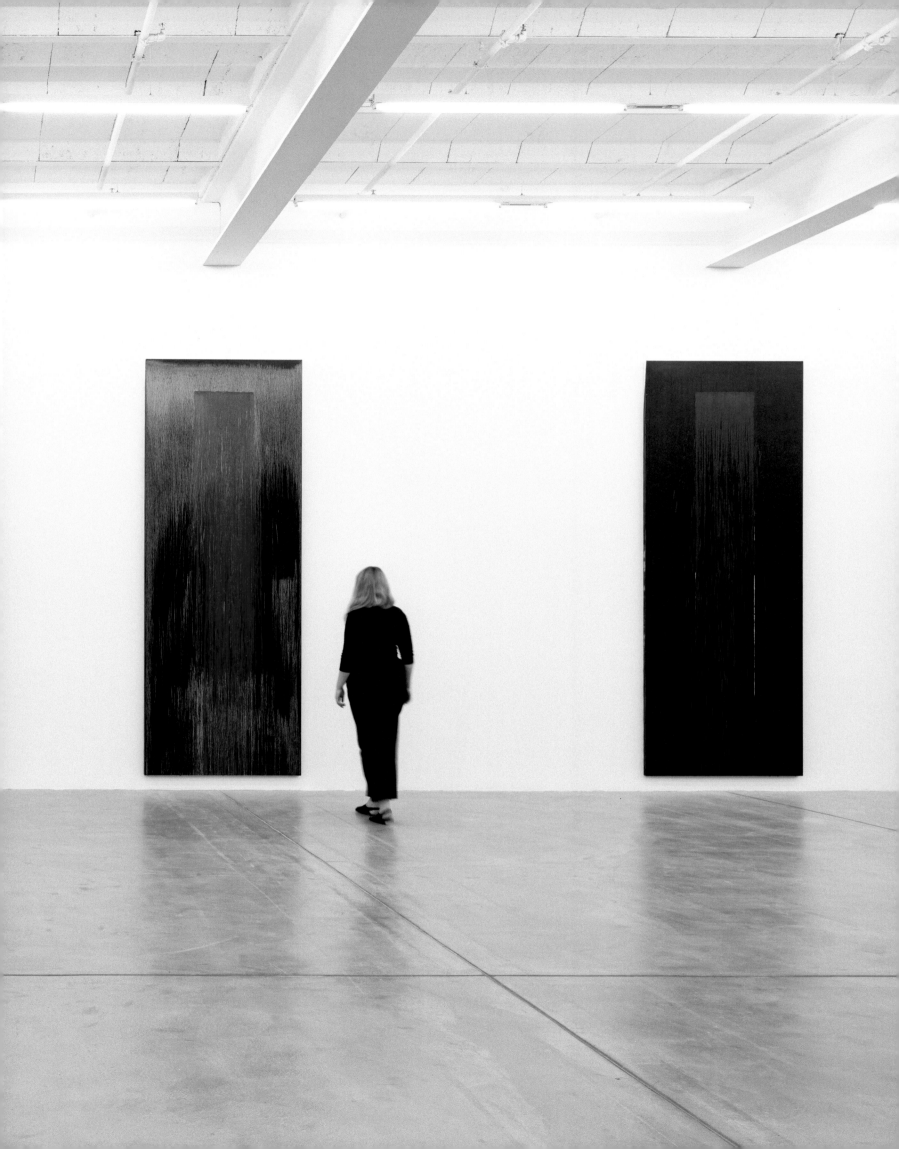

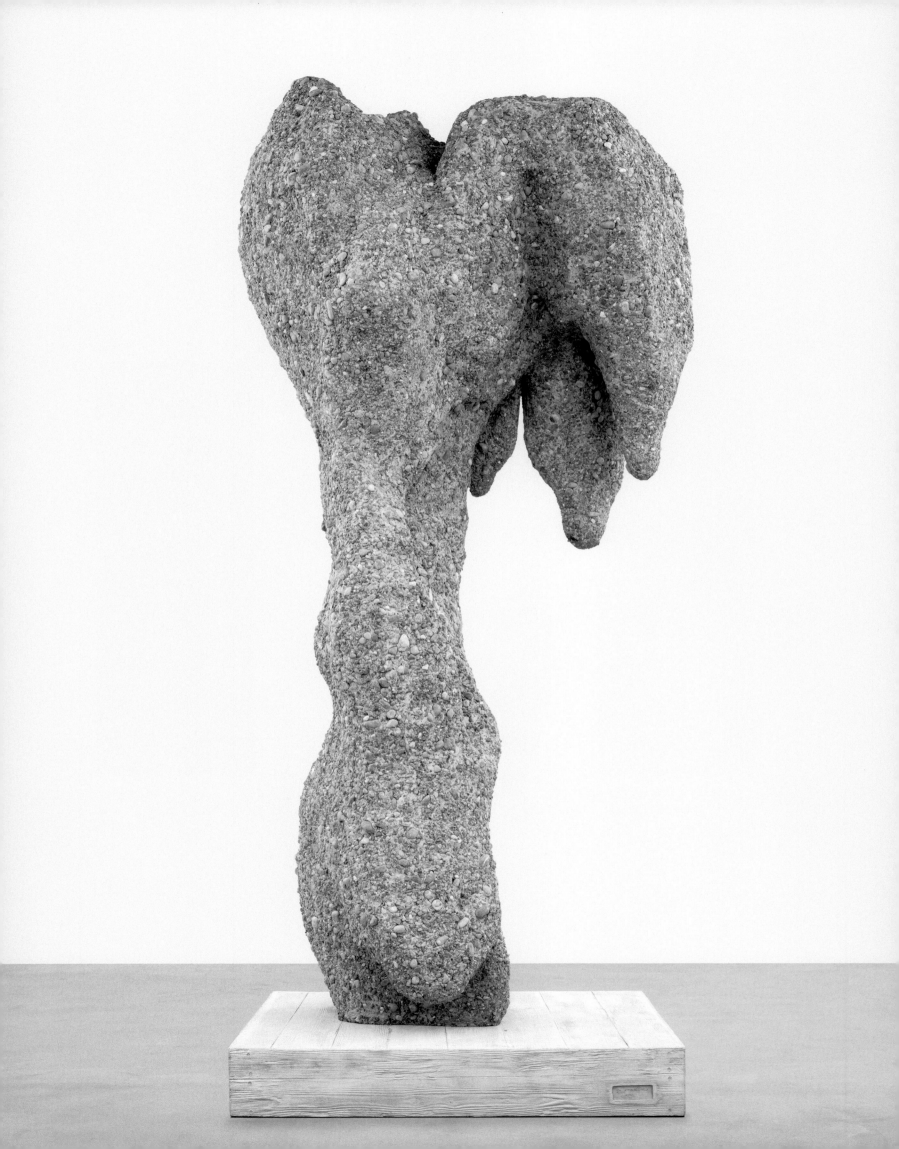

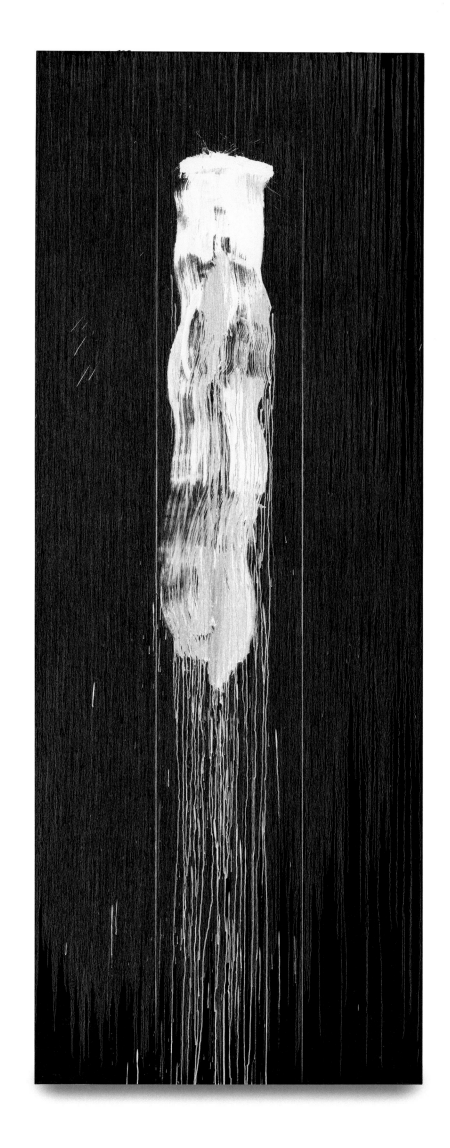

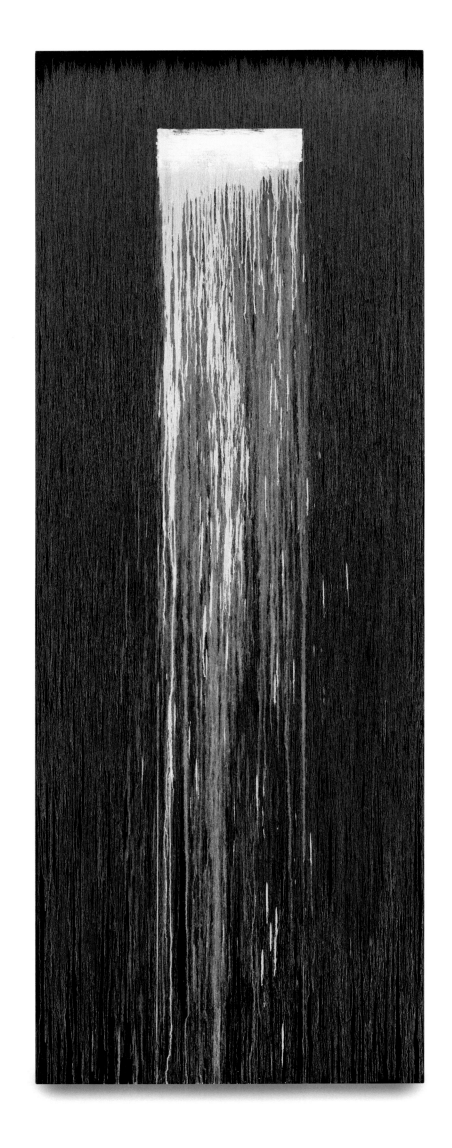

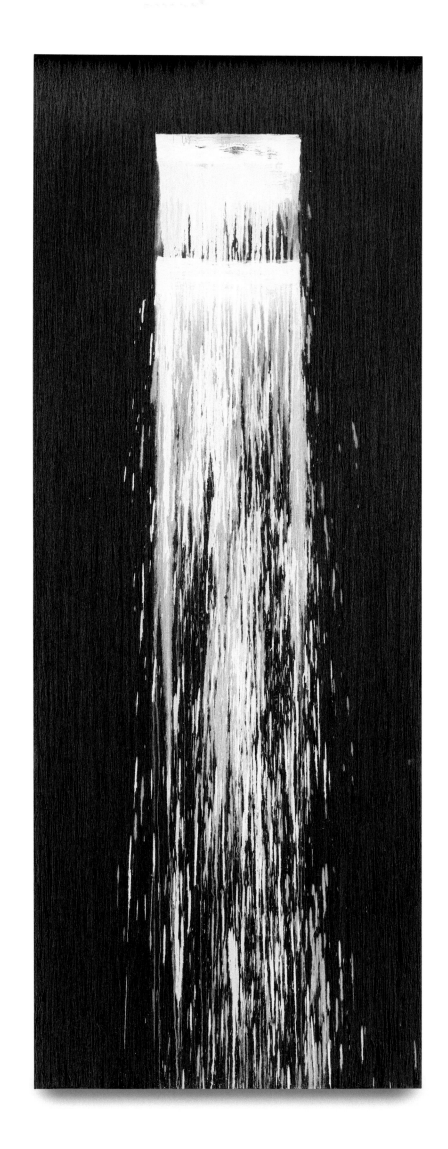

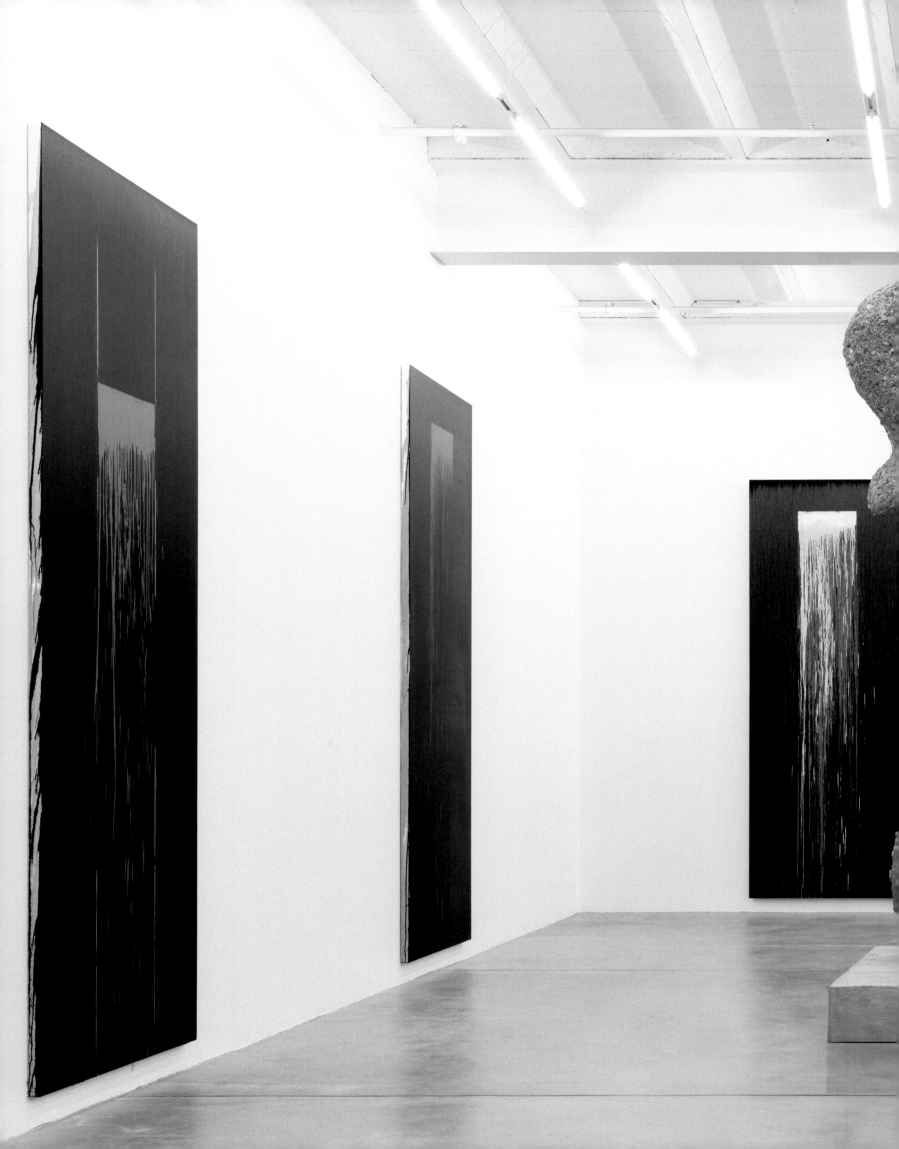

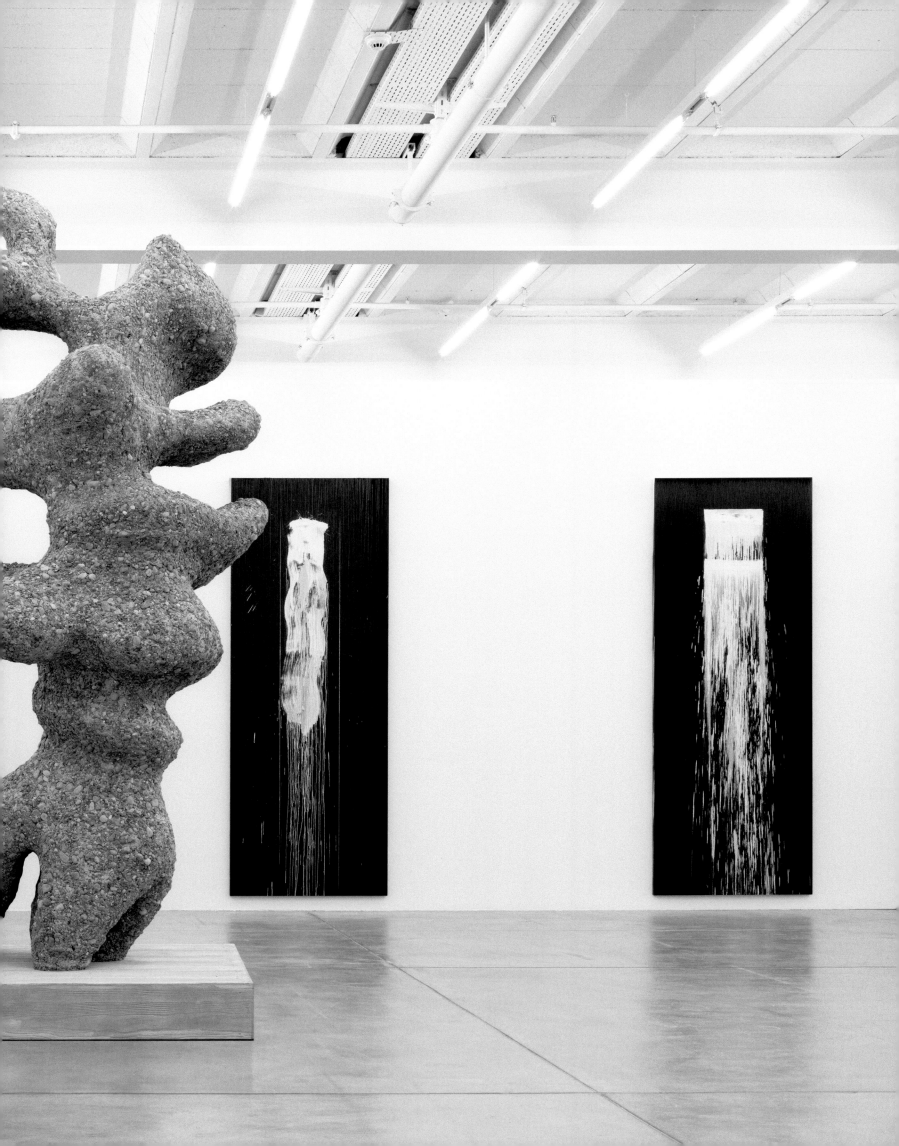

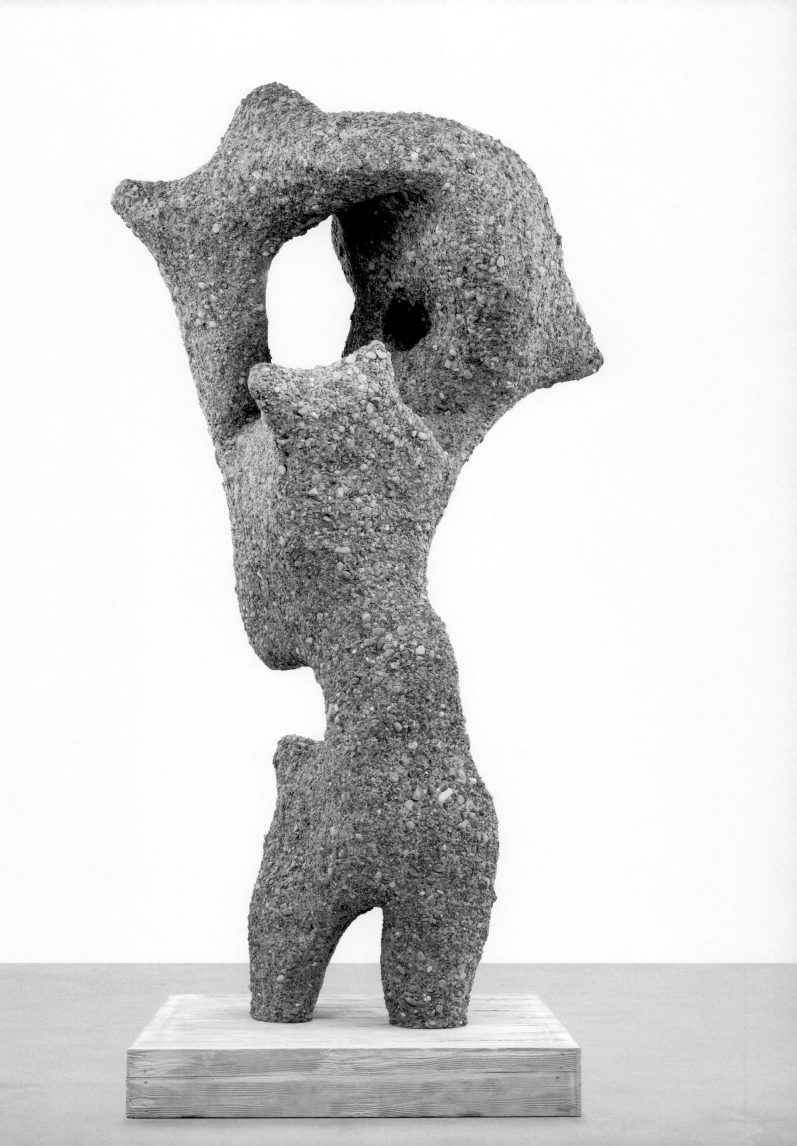

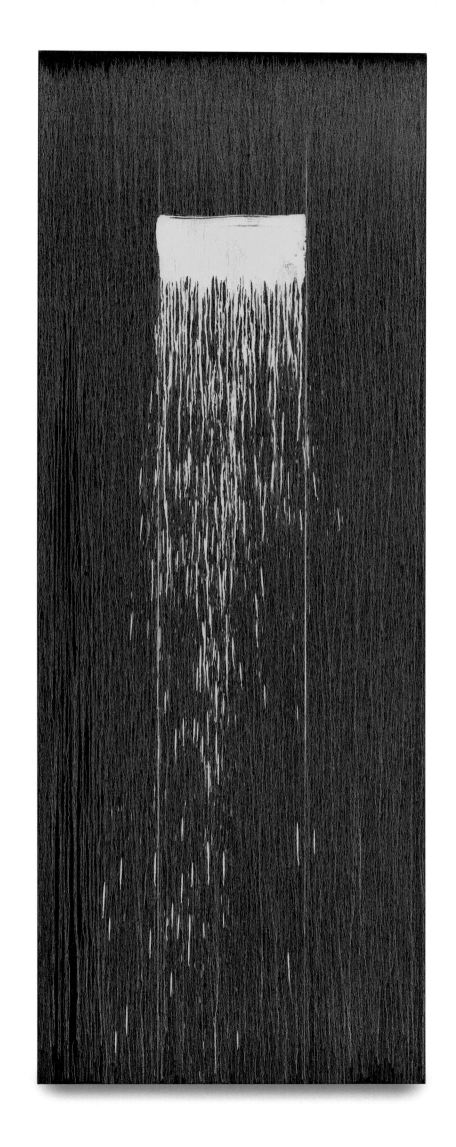

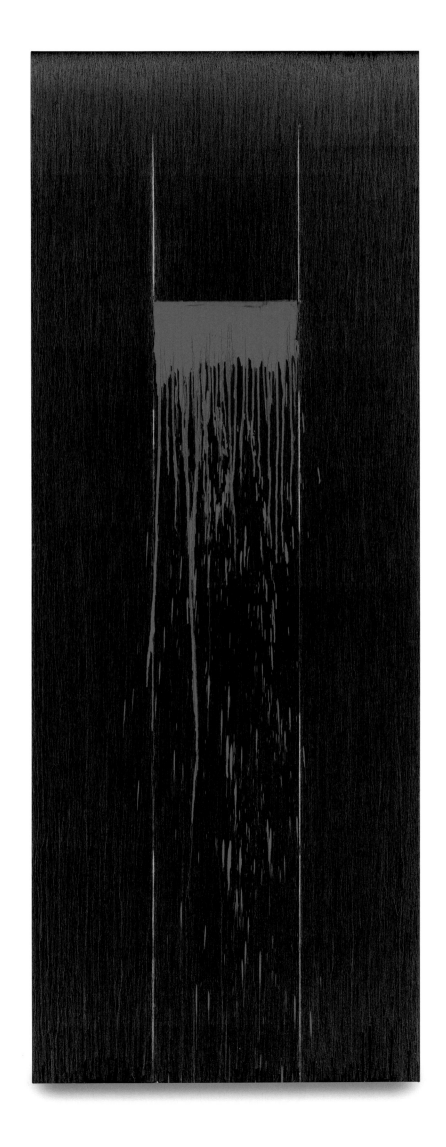

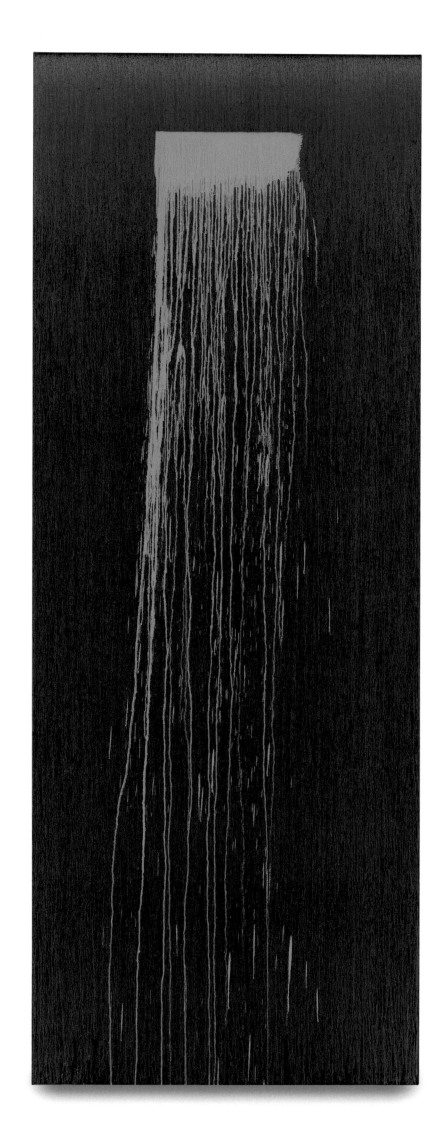

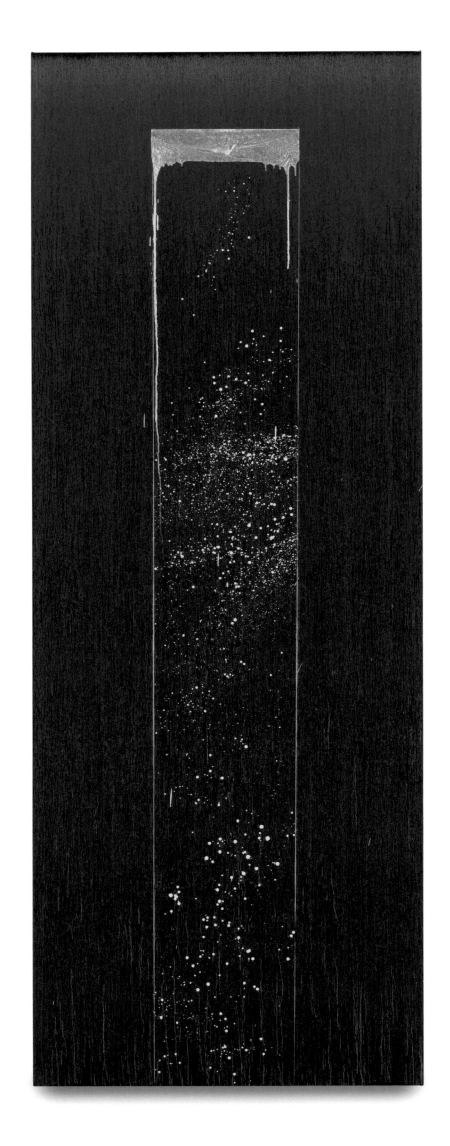

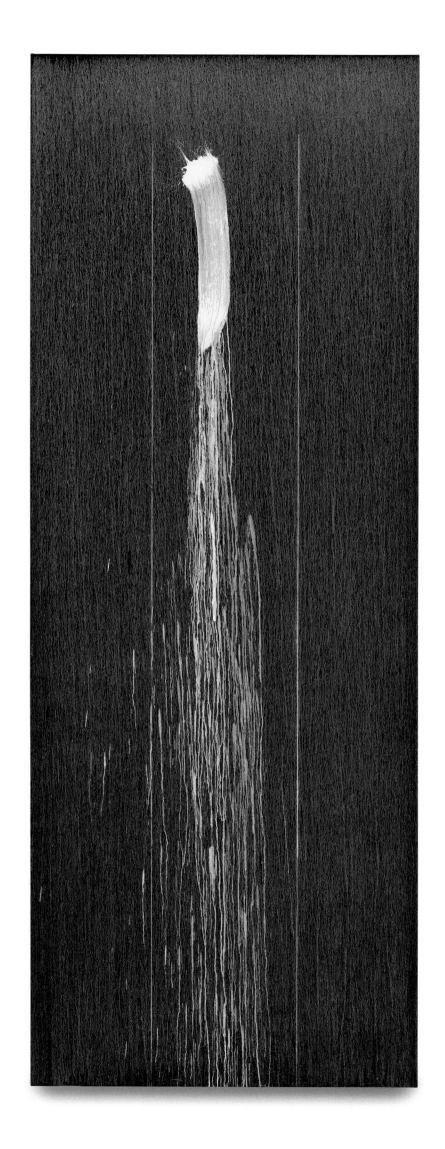

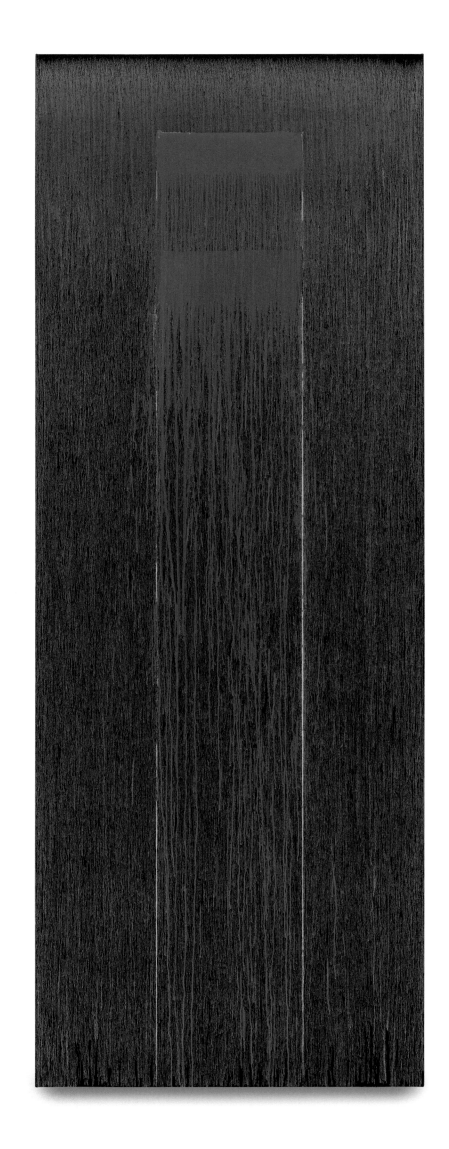

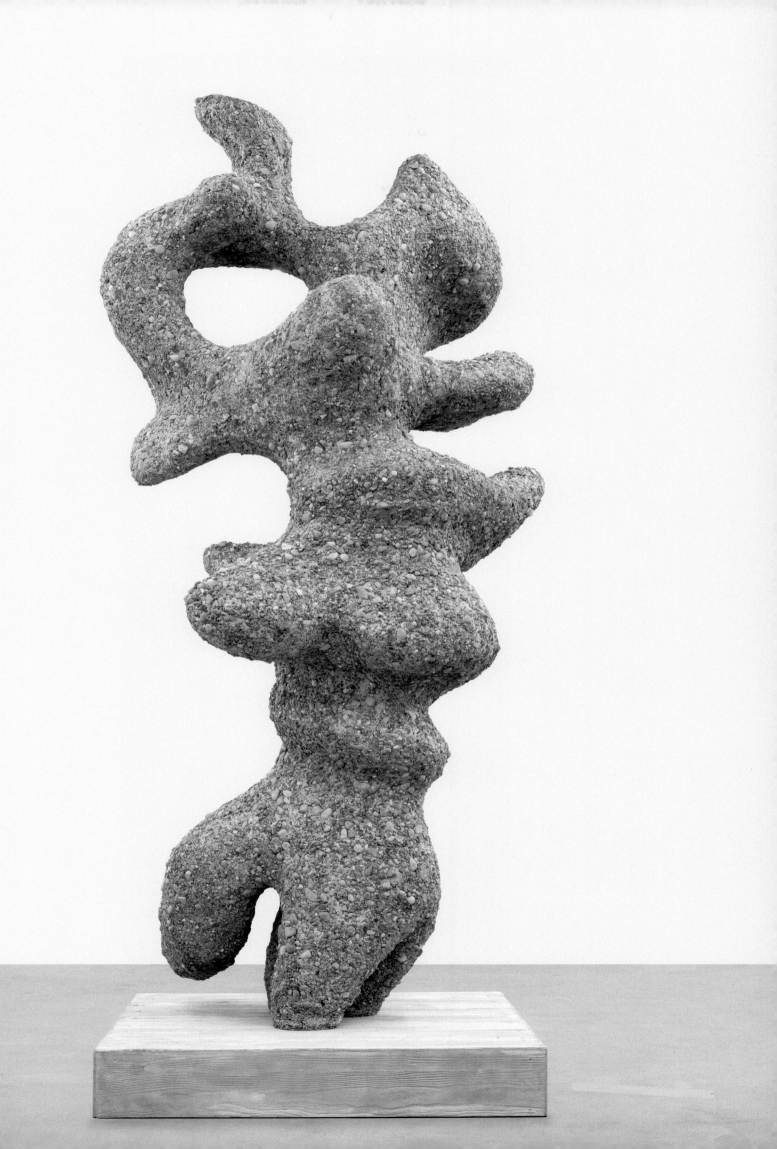

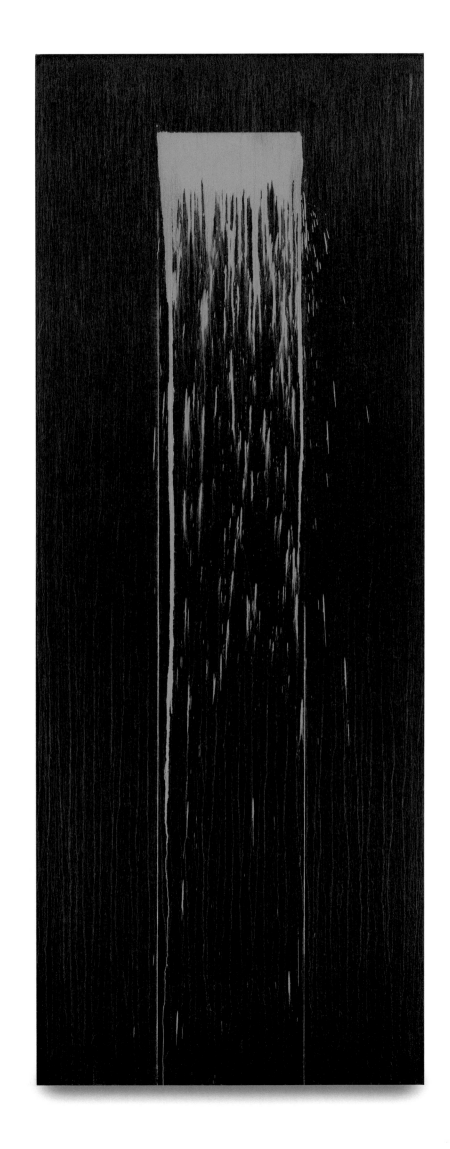

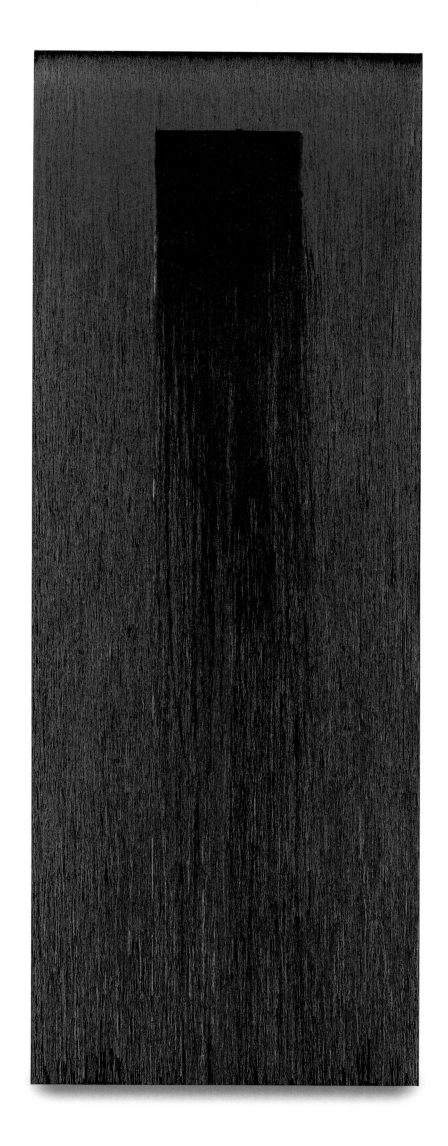

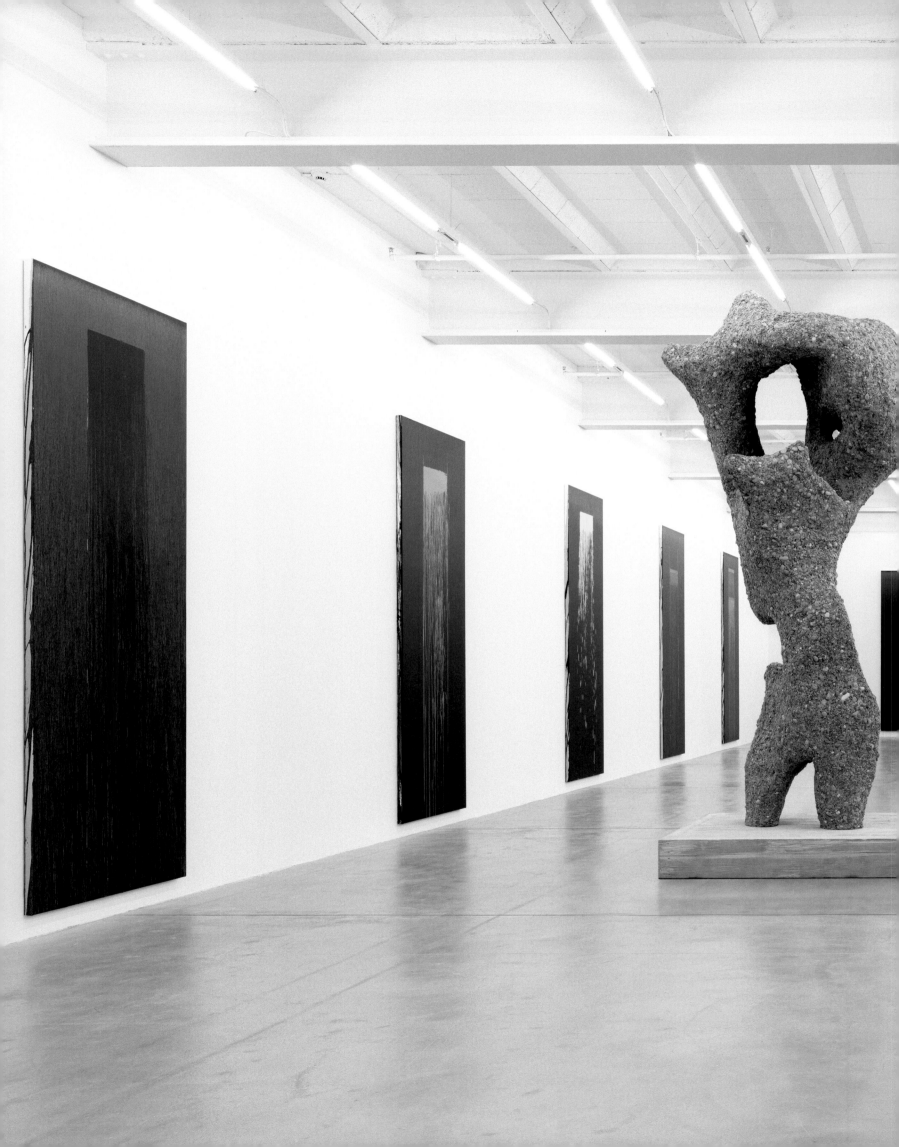

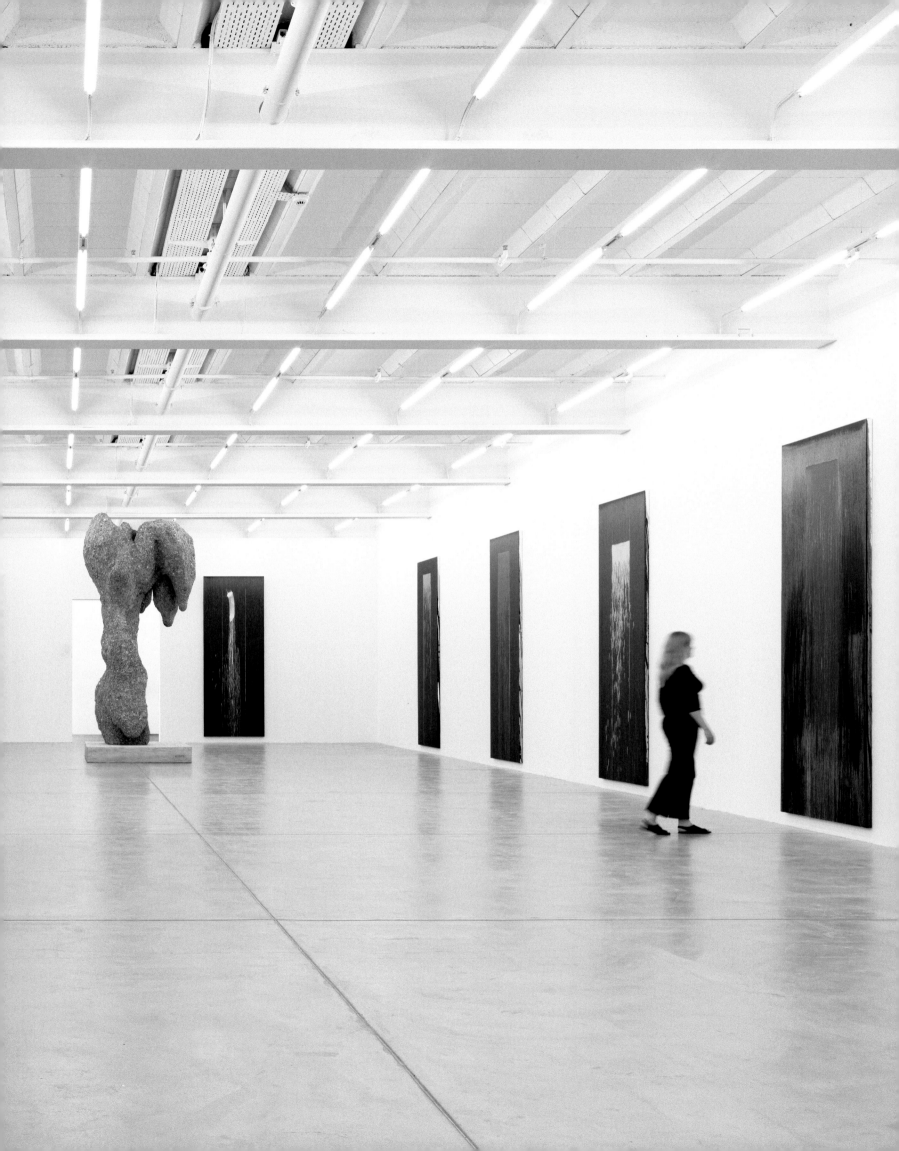

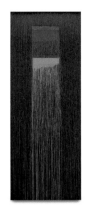
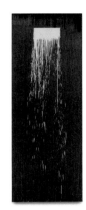

Flags for Ugo #1, 2021
Oil on canvas
335.5 × 122 × 4.5 cm / 132 × 48 × 1¾ in.

Flags for Ugo #2, 2021
Oil on canvas
335.5 × 122 × 4.5 cm / 132 × 48 × 1¾ in.

Flags for Ugo #3, 2021
Oil on canvas
335.5 × 122 × 4.5 cm / 132 × 48 × 1¾ in.

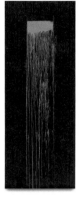
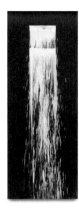
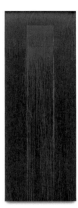

Flags for Ugo #4, 2021
Oil on canvas
335.5 × 122 × 4.5 cm / 132 × 48 × 1¾ in.

Flags for Ugo #5, 2021
Oil on canvas
335.5 × 122 × 4.5 cm / 132 × 48 × 1¾ in.

Flags for Ugo #6, 2021
Oil on canvas
335.5 × 122 × 4.5 cm / 132 × 48 × 1¾ in.

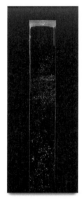
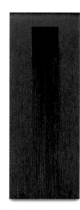
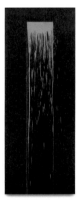

Flags for Ugo #7, 2021
Oil on canvas
335.5 × 122 × 4.5 cm / 132 × 48 × 1¾ in.

Flags for Ugo #8, 2021
Oil on canvas
335.5 × 122 × 4.5 cm / 132 × 48 × 1¾ in.

Flags for Ugo #9, 2021
Oil on canvas
335.5 × 122 × 4.5 cm / 132 × 48 × 1¾ in.

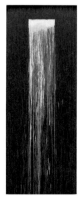
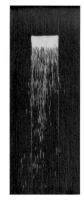
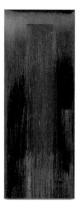

Flags for Ugo #10, 2021
Oil on canvas
335.5 × 122 × 4.5 cm / 132 × 48 × 1¾ in.

Flags for Ugo #11, 2021
Oil on canvas
335.5 × 122 × 4.5 cm / 132 × 48 × 1¾ in.

Flags for Ugo #12, 2021
Oil on canvas
335.5 × 122 × 4.5 cm / 132 × 48 × 1¾ in.

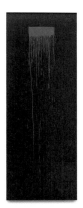

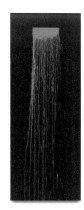

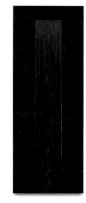

Flags for Ugo #13, 2021
Oil on canvas
335.5 × 122 × 4.5 cm / 132 × 48 × 1¾ in

Flags for Ugo #14, 2021
Oil on canvas
335.5 × 122 × 4.5 cm / 132 × 48 × 1¾ in

Flags for Ugo #15, 2021
Oil on canvas
335.5 × 122 × 4.5 cm / 132 × 48 × 1¾ in

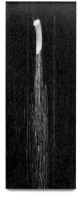

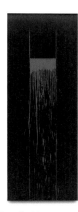

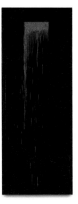

Flags for Ugo #16, 2021
Oil on canvas
335.5 × 122 × 4.5 cm / 132 × 48 × 1¾ in.

Flags for Ugo #17, 2021
Oil on canvas
335.5 × 122 × 4.5 cm / 132 × 48 × 1¾ in.

Flags for Ugo #18, 2021
Oil on canvas
335.5 × 122 × 4.5 cm / 132 × 48 × 1¾ in.

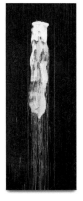

Flags for Ugo #19, 2021
Oil on canvas
335.5 × 122 × 4.5 cm / 132 × 48 × 1¾ in.

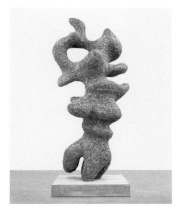

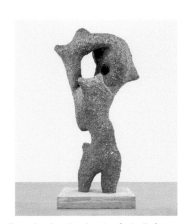

we run through a desert on burning feet, all of us are glowing
our golden FACES look twisted and shiny., 2008
Sand, gravel, concrete
Sculpture 380 × 182 × 183 cm / 149⅝ × 71⅝ × 72 in.
Pedestal 25.5 × 160.5 × 160.5 cm / 10 × 63¼ × 63¼ in.

we run through a desert on burning feet, all of us are glowing
our golden faces LOOK twisted and shiny., 2008
Sand, gravel, concrete
Sculpture 376 × 191 × 180.5 cm / 148 × 75¼ × 71⅛ in.
Pedestal 25 × 160.5 × 161 cm / 9⅘ × 63¼ × 63⅜ in.

we run through a desert on burning feet, all of us are glowing
our golden faces look TWISTED and shiny., 2008
Sand, gravel, concrete
Sculpture 378 × 178 × 148 cm / 148⅛ × 70 1/8 × 58¼ in.
Pedestal 25 × 160.5 × 161 cm / 9⅘ × 63¼ × 63⅜ in.

biography

pat steir

1940
born iris patricia sukoneck in newark,
new jersey

education

2008
distinguished alumni award, pratt institute,
brooklyn

2001
distinguished alumni award, boston university,
college of fine arts, school of visual arts, boston

1991
honorary doctorate of fine arts,
pratt institute, brooklyn

1962
bfa, pratt institute, brooklyn

1960–62
studied at pratt institute, brooklyn

1960
bfa, boston university, college of fine arts,
school of visual arts, boston

1958–60
studied at boston university, college of fine arts,
school of visual arts, boston

1956–58
studied graphic art at pratt institute, brooklyn

2021
pat steir, long museum, west bund, shanghai
pat steir: considering rothko, lévy gorvy, palm
beach

2020
pat steir: waterfall paintings on paper, lévy gorvy,
new york
pat steir: paintings from the east, vito schnabel
gallery, st. moritz

2019
pat steir: color wheel, hirshhorn museum and
sculpture garden, washington, dc
pat steir, locks gallery, philadelphia
paintings, vito schnabel gallery, st. moritz
silent secret waterfalls: the barnes series, barnes
foundation, philadelphia

2018
*pat steir: self portrait installation, 1987–2018 and
paintings*, galerie thomas schulte, berlin

2017
pat steir: kairos, lévy gorvy, new york

2016
dominique lévy gallery, london
pace prints, new york
pat steir: the floating line, t space, rhinebeck,
new york
pat steir: drawings, helen day art center, stowe,
vermont

2014
cheim & read, new york
pat steir: for philadelphia, locks gallery,
philadelphia
pat steir: waterfalls, meyerovich gallery,
san francisco

2013
pat steir: new paintings, baldwin gallery, aspen
endless line & self portrait, newcomb art gallery,
tulane university, new orleans
self portrait and heartline, museo nacional de
san carlos, mexico city
pat steir: hand-painted monotypes, pace prints,
new york
pat steir: blue river, national academy museum,
new york

2012
pat steir: a view, academy art museum, easton,
maryland
crown point press, san francisco

2011
winter paintings, cheim & read, new york
another nearly endless line, whitney museum of
american art, new york
water and sand, locks gallery, philadelphia
a nearly endless line #3, galerie thomas schulte,
berlin

2010
pat steir: the nearly endless line, sue scott
gallery, new york
paint, galerie jaeger bucher, paris
pat steir: water & stone, contemporary arts
center, cincinnati
pat steir: drawing out of line, museum of art,
rhode island school of design, providence;
traveled to neuberger museum of art,
purchase, new york
self portrait: an installation, purchase college,
new york

2009
paintings on painting, locks gallery, philadelphia
pat steir self-portrait: reprise 1987–2009, new
york studio school

2008
pat steir recent work: paintings & monotypes,
elizabeth leach gallery, portland, oregon
pat steir: new monoprints, pace prints, new york

bentley gallery, scottsdale, arizona
pat steir: prints and paintings, carl solway
gallery, cincinnati

2007
cheim & read, new york
reykjavík art museum
rosenbaum contemporary, boca raton, florida

2006
pat steir: gravity and levity, baldwin gallery,
aspen
pat steir: moons and mirages, locks gallery,
philadelphia
small paintings from the studio of pat steir, kiang
gallery, atlanta
bentley gallery, scottsdale, arizona

2005
pat steir: new paintings, texas gallery, houston
*pat steir, blue moon: paintings, drawings, and
prints*, galleria alessandra bonomo, rome
moons and a river, cheim & read, new york
pat steir: drawings, cook fine art, new york
prints and monotypes, pace prints, new york

2004
ochi fine art, ketchum, idaho

2003
the rhythm of silence, locks gallery, philadelphia
monotypes, pace prints, new york
water and air, galleria nazionale d'arte
moderna, rome
des moines art center
waterfall paintings, boise art museum

2002
colors and other colors on top, university of
michigan art museum, ann arbor
kiang gallery, atlanta
new paintings, baldwin gallery, aspen
crown point press, san francisco
galleria alessandra bonomo, rome
cheim & read, new york

2001
contemporary arts museum, honolulu
*red yellow blue i love you: wall paintings by
pat steir*, madison art center, wisconsin
distant horizon, galleria bonomo, bari, italy
recent prints, sherman gallery, boston university
sweet suite, galerie simonne stern, new orleans
waterfall de reves, piece unique, paris

2000
*dazzling water, dazzling light: paintings by pat
steir*, selby gallery, ringling school of art and
design, sarasota, florida; traveled to butler
institute of american art, youngstown, ohio; des
moines art center; lyman allyn museum of art at
connecticut college, new london; norton
museum of art, sarasota, florida
massachusetts college of art, boston
leigh and mary block art museum, northwestern
university, evanston, illinois
chancery of the united states embassy, moscow
lyrical waterfalls: a collection of paintings,
artcore, toronto
waterfall paintings, rhona hoffman gallery,
chicago

1999
baldwin gallery, aspen
moon mountain ghost water, marlborough
gallery, new york
my garden ghosts, albright-knox art gallery,
buffalo, new york
double-sided painting, piece unique, paris
5 easy pieces, university of north carolina,
weatherspoon art gallery, greensboro, north
carolina
nina freudenheim gallery, buffalo, new york

1998
ghost moon mountain water, ps1 contemporary
art center, long island city, new york
new work, baumgartner galleries, washington, dc

recent paintings, rhona hoffman gallery, chicago
bentley gallery, scottsdale, arizona
wind water stone, robert miller gallery, new york

1997
waterfalls, galerie deux co, ltd, tokyo
pat steir: waves and waterfalls 1982–1992,
brooklyn museum

1996
dorothy blau gallery, bay harbor islands, florida
franck & schulte, berlin
wind and water: paintings 1985–1995, irish
museum of modern art, dublin

1995
le quartier, centre d'art contemporain de
quimper, france
pat steir: new paintings, robert miller gallery,
new york
new work: paintings and works on paper,
baldwin gallery, aspen
franck & schulte, berlin
kunst-werke institute for contemporary art,
berlin
black & white, museum d'art moderne, print
cabinet, geneva

1994
from beyond the pale: pat steir: a painting
project, irish museum of modern art, dublin
jaffe baker blau, boca raton, florida
paintings and etchings, anders tornberg gallery,
lund, sweden
dennis ochi gallery, boise and sun valley, idaho

1993
guild hall museum, east hampton, new york
galleria alessandra bonomo, rome
wall drawings, franck & schulte, berlin

1992
centre national d'art contemporain de
grenoble, france
elective affinities, robert miller gallery, new york

1991
paintings, galerie albert baronian, brussels
franck & schulte, berlin
linda cathcart gallery, santa monica, california
self-portrait installation, mackenzie art gallery,
regina, canada

1990
waterfalls, victoria miro gallery, london
paintings, contemporary art museum, university
of south florida, tampa
waterfall paintings, robert miller gallery, new york
galerie montenay, paris
conversations with artists, national gallery of art,
washington, dc
musée d'art contemporain de lyon
ways of seeing: paintings, drawings, prints of the
1980s, new jersey center for the visual arts,
summit, new jersey
drawings, dennis ochi gallery, boise and sun
valley, idaho

1989
new waterfall paintings, galerie eric franck,
geneva
neue wasserfallbilder, transart exhibitions,
cologne
galleria marilena bonomo, bari, italy
waterfall paintings, massimo audiello gallery,
new york
waterfall paintings, fuller gross gallery,
san francisco
new works, harcus gallery, boston
new monoprints, crown point press, new york
and san francisco
waterfall monoprints, crown point press,
new york and san francisco

1988
prints 1976–1988, musée d'art et d'histoire,
cabinet des estampes, geneva; traveled to tate
gallery, london; victoria miro gallery, london

galleria marilena bonomo, bari, italy
waterfall series, m. knoedler & co., new york

1987
paintings and drawings, kunstmuseum bern
self portrait: an installation, galerie adelina
von furstenberg, geneva
drawing now: pat steir, baltimore museum of art
autorittrato, galleria alessandra bonomo, rome
paintings, 1981–84, rijksmuseum vincent van
gogh, amsterdam
galerie eric franck, geneva
the moon and the wave, m. knoedler & co.,
new york
self portrait: installation, new museum of
contemporary art, new york

1986
concentrations 14: pat steir, dallas museum of art
new paintings, kuhlenschmidt/simon gallery,
los angeles
harcus gallery, boston
fuller goldeen gallery, san francisco
john c. stoller & co., minneapolis
castelli uptown, new york
new monoprints and etchings, crown point
press, new york

1985
peintures 1981–1985, galerie eric franck, geneva,
major prints and drawings, dolan/maxwell
gallery, philadelphia
new drawings, cincinnati art museum
fuller goldeen gallery, san francisco
prints/printmaking, philadelphia college of art

1984
pat steir, the breughel series (a vanitas of style),
brooklyn museum; traveled to minneapolis
college of art and design; joslyn art museum,
omaha, nebraska; university art museum,
university of california, berkeley; ohio state
university gallery of fine art, columbus;
honolulu academy of arts; dallas museum of
fine arts; centre d'art contemporain, palais
wilson, geneva; los angeles county museum
of art; des moines art center; haags
gemeentemuseum, the hague
new work, nina freudenheim gallery, buffalo,
new york
new paintings, galleriet, lund, sweden
new paintings and works on paper, van straaten
gallery, chicago
new paintings, galerie barbara farber, amsterdam
real art ways, hartford, connecticut
signet art gallery, st. louis
paintings and etchings, anders tornberg gallery,
lund, sweden

1983
at sea, 1982, crown point press, new york
arbitrary order: paintings by pat steir,
contemporary arts museum, houston; traveled
to lowe art museum, coral gables, florida;
contemporary arts center, cincinnati
form illusion myth: the prints and drawings of pat
steir, spencer museum of art, university of
kansas, lawrence; traveled to university art
museum, california state university, long beach;
contemporary arts museum, houston; wellesley
college museum, massachusetts; brooks
memorial art gallery, memphis
fuller goldeen gallery, san francisco
mcintosh/drysdale gallery, houston
studies for the breughel series, galleria
marilena bonomo, bari, italy
gloria luria gallery, bay harbor islands, florida
harcus gallery, boston

1982
eason gallery, santa fe, new mexico
galerie annemarie verna, zürich
galerie farideh cadot, paris
watercolors, nina freudenheim gallery, buffalo,
new york

1981
etchings, lithos, and drawings, galleriet, lund,
sweden
etchings and paintings, crown point press
gallery, oakland, california
brown university, list art center, bell art gallery,
providence, rhode island
galleria marilena bonomo, bari, italy
galerie farideh cadot, paris
marianne deson gallery, chicago
max protetch gallery, new york

1980
droll/kolbert gallery, new york
galerie farideh cadot, paris
galerie d'art contemporain, geneva
max protetch gallery, new york

1979
galerie farideh cadot, paris

1978
art school for children, birmingham, alabama
droll/kolbert gallery, new york
galerie farideh cadot, paris
galleria marilena bonomo, bari, italy

1977
carl solway gallery, cincinnati

1976
art gallery, university of maryland, college park,
maryland
galerie farideh cadot, paris
morgan thomas gallery, santa monica, california
otis art institute, los angeles
white gallery, portland state university
xavier fourcade, inc., new york

1975
fourcade, droll, inc., new york
john doyle gallery, paris
state university of new york, oneonta

1973
ball state university art gallery, muncie, indiana
corcoran gallery of art, washington, dc
max protetch gallery, washington, dc

1972
douglass college, rutgers university, new
brunswick, new jersey
paley & lowe, inc., new york

1971
graham gallery, new york

1969
bienville gallery, new orleans

1964
terry dintenfass gallery, new york

biography

ugo rondinone

1964
born in brunnen, switzerland

1986–90
studied at the hochschule für angewandte kunst, vienna

lives and works in new york

solo exhibitions ugo rondinone

2021
vocabulary of solitude, museo tamayo, mexico
nude in the landscape, belvedere 21, vienna
a low sun . golden mountains . fall, galerie krobath, vienna
waterfalls & clouds, two-person show with pat steir, galerie eva presenhuber, zürich
sail me on a silver sun, the national exemplar, iowa city
still.life., journal gallery, new york
your age and my age and the age of the rainbow, belvedere, vienna
a rainbow . a nude . bright light . summer, kamel mennour, paris
a yellow a brown and a blue candle, the national exemplar, iowa city
nuns + monks, gladstone gallery, new york
chuck nanney + joel otterson, curated by ugo rondinone, martos gallery, new york
ned smyth — life, curated by ugo rondinone, the landcraft garden, mattituck
a sky . a sea . distant mountains . horses . spring ., sadie coles, london
feeling the void and the rhone, kunsthalle marcel duchamp, cully
a wall. a door. a tree. a lightbulb. winter, skmu sørlandets kunstmuseum, kristiansand

2020
the monk, sant'andrea de scaphis, rome
nuns + monks, esther schipper, berlin
nuns + monks, galerie eva presenhuber, zürich
poetry, two-person show with john dilg, the national exemplar, iowa city

2019
medellín mountain, medellín modern art museum, colombia
thanx 4 nothing, gladstone gallery, new york
a wall . seven windows . four people . three trees . some clouds . one sun, kamel mennour, paris
everyone gets lighter, kunsthalle helsinki, finland
sunny days, guild hall, east hampton
thanx 4 nothing, carré d'art, chapelle des jésuites, nîmes
earthing, kukje gallery, seoul

2018
the true, laguna gloria, the contemporary austin
liverpool mountain, liverpool biennial, tate liverpool
clockwork for oracles, phillips, paris
the marciano collection, marciano foundation, los angeles
the radiant, malta international contemporary art space, valetta
drifting clouds, gladstone gallery, new york
your age and my age and the age of the sun, fundación casaw abi, puerto escondido

2017
vocabulary of solitude, arken museum of modern art, ishøj
moonrise. east. july, aspen art museum, aspen
good evening beautiful blue, bass museum of art, miami
flower moon, bristol hotel, paris
where do we go from here, the istanbul biennial, istanbul
i love john giorno, various institutions, new york, *the sky over manhattan*, sky art, new york
the world just makes me laugh, berkeley art museum and pacific film archive, berkeley
let's start this day again, contemporary arts center, cincinnati
winter moon, maxxi, rome
your age and my age and the age of the rainbow, garage museum of contemporary art, moscow

2016
every time the sun comes up, place vendôme, paris
two men contemplating the moon 1830, esther schipper, berlin
miami mountain, bass museum of art, miami
the sun at 4pm, gladstone gallery, new york
girono d'oro + notti d'argento, mercati di traiano, rome
girono d'oro + notti d'argento, macro, rome

becoming soil, carré d'art, nîmes
seven magic mountains, public art production fund and nevada museum of art / desert of nevada
vocabulary of solitude, boijmans van beuningen, rotterdam
primordial, gladstone gallery, brussels
ugo rondinone: moonrise sculptures, the institute of contemporary art (ica), boston
windows, poems, and stars, la caja negra, madrid

2015
i love john giorno, palais de tokyo, paris
mountains + clouds + waterfalls, sadie coles hq, london
feelings, kukje gallery, seoul
walls + windows + doors, galerie eva presenhuber, zürich
golden days and silver nights, art gallery of nsw, sydney
artists and poets, curated by ugo rondinone, secession, vienna
clouds, galerie krobath, vienna

2014
breathe walk die, rockbund art museum, shanghai
naturaleza humana, museo anahuacalli, coyoacán

2013
human nature, public art fund, rockefeller plaza, new york
we run through a desert on burning feet, all of us are glowing our faces look twisted, art institute of chicago, chicago
thank you silence, m museum, leuven
pure moonlight, almine rech gallery, paris
primal, esther schipper, berlin
soul, gladstone gallery, new york
soul, galerie eva presenhuber, zürich
primal, sommer contemporary art, tel aviv
poems, sorry we're closed, brussels
fatima center for contemporary culture, monterrey

2012
primitive, the common guild, glasgow
pure sunshine, sadie coles hq, london
nude, cycladic art museum, athens
wisdom?peace?blank?all of this?, kunst-historisches museum, theseustempel, vienna
the moth poem and the holy forest, galerie krobath, vienna

2011
we are poems, gladstone gallery, brussels
new horizon, almine rech gallery, brussels
we are poems, lvmh, palais an der oper, munich
kiss now kill later, galerie eva presenhuber, zürich
we run through a desert on burning feet, all of us are glowing our faces look twisted, art basel, art parcours, basel
outside my window, peder lund, oslo

2010
nude, gladstone gallery, new york
ibm building, new york
turn back time. let's start this day again, fiac, hors les murs, jardins des tuileries, paris
clockwork for oracles, art basel, art unlimited, basel
sunrise. east, museum dhondt-dhaenens, deurle
die nacht aus blei, aargauer kunsthaus, aarau

2009
sunrise. east, festival d'automne à paris, jardin des tuileries, paris
how does it feel?, festival d'automne à paris, le 104, paris
nude, sadie coles hq, london
la vie silencieuse, galerie almine rech, paris
the night of lead, musac, museo de arte contemporáneo de castilla, léon

2008
clockwork for oracles ii, ica boston, art wall
project, boston
turn back time. let's start this day again, galleria
raucci/santamaria, naples
sunrise. east, frieze art fair, outdoor project,
london
we burn, we shiver (with martin boyce),
sculpture center, new york
moonrise. east, public art project, art basel,
basel
twelve sunsets, twenty nine dawns, all in one,
galerie eva presenhuber, zürich
dog days are over, hayward gallery, southbank
centre, london

2007
big mind sky, matthew marks gallery, new york
wohnsiedlung werdweis, kunst und bau,
zürich-altstetten
get up girl a sun is running the world (with urs
fischer), church san stae, 52nd venice biennale,
venice
our magic hour, arario gallery, cheonan
air gets into everything even nothing, creative
time, ritz carlton plaza, battery park, new york

2006
giorni felici, galleria civica di modena, modena
on butterfly wings, galerie almine rech, paris
thank you silence, matthew marks gallery,
new york
unday, galerie esther schipper, berlin
a waterlike still, ausstellungshalle zeitgenös-
sische kunst, munster
my endless numbered days, sadie coles hq,
london
zero built a nest in my navel, whitechapel gallery,
london

2005
clockwork for oracles, isr - centro culturale
svizzero di milano, milan
sunsetsunrise, sommer contemporary art,
tel aviv

2004
sail me on a silver sun, galleria raucci/santamaria,
naples
long gone sole, matthew marks gallery, new york
long night short years, le consortium, dijon
clockwork for oracles, australian centre for
contemporary art, melbourne

2003
la criée, théâtre national de bretagne, galerie art
& essai, rennes
moonrise, galerie hauser & wirth & presenhuber,
zürich
our magic hour, museum of contemporary art,
sydney
lessness, galerie almine rech, paris
roundelay, musée national d'art moderne, centre
georges pompidou, paris

2002
in alto arte sui ponteggi, centro culturale svizzero,
milan
our magic hour, centre for contemporary visual
arts, brighton
coming up for air, württembergischer kunstverein,
stuttgart
1988, works on paper inc., los angeles
lowland lullaby (with urs fischer), swiss institute,
new york
cigarettesandwich, sadie coles hq, london
the dancer and the dance, galerie krobath
wimmer, vienna
no how on, kunsthalle wien, vienna
a horse with no name, matthew marks gallery,
new york
on perspective, galleri faurschou, copenhagen

2001
slow graffiti, galerie schipper & krome, berlin
frac paca, marseille
yesterday's dancer, sommer contemporary art,
tel aviv

dreams and dramas, herzliya museum of
contemporary art, herzliya
kiss tomorrow goodbye, palazzo delle
esposizioni, rome
if there were anywhere but desert, galerie almine
rech, paris

2000
so much water so close to home, moma p.s.1,
new york
love invents us, matthew marks gallery, new
york
if there were anywhere but desert, mont-blanc
boutique, new york
a doubleday and a pastime, galleria raucci/
santamaria, naples
in the sweet years remaining, aarhus art museum,
aarhus
hell, yes!, sadie coles hq, london

1999
guided by voices, galerie für zeitgenössische
kunst leipzig, leipzig
guided by voices, kunsthaus glarus, glarus
moonlighting, galerie hauser & wirth &
presenhuber, zürich
light of fallen stars, yves saint-laurent, new york
in the sweet years remaining, schipper & krome,
berlin

1998
in the sweet years remaining, galerie joão graça,
lisbon
the evening passes like any other, galerie almine
rech, paris
so much water so close to home, galerie krobath
wimmer, vienna

1997
stillsmoking, galleria raucci/santamaria, naples
moonlight and aspirin, galleria bonomo, rome
tender places come from nothing, cato jans der
raum, hamburg
where do we go from here, le consortium, dijon

1996
dog days are over, migros museum für
gegenwartskunst, zürich
le case d'arte, milan
heyday, centre d'art contemporain, geneva

1995
meantime, galerie froment-putman, paris
migrateurs, arc – musée d'art moderne de la
ville de paris, paris
cry me a river, galerie walcheturm, zürich

1994
galerie daniel buchholz, cologne
galerie six friedrich, munich

1993
drawings, centre d'art contemporain de martigny,
martigny
lightyears, galerie ballgasse, vienna

1992
c, galerie walcheturm, zürich

1985–1991
far away trains passing by, galerie martina
detterer, frankfurt
two stones in my pocket, galerie pinx, vienna
i'm a tree, galerie walcheturm, zürich
galerie pinx, vienna
raum für aktuelle schweizer kunst, lucerne
sec 52, ricco bilger, zürich
galerie marlene frei, zürich

imprint

this catalogue was published on the
occasion of the exhibition
waterfalls & clouds
galerie eva presenhuber, zürich
september 4–october 16, 2021

design
book book, berlin

text
barry schwabsky

photography
stefan altenburger

production
dcv

typeface
grotesque mt

paper
gardapat bianka

print
dza druckerei zu altenburg, altenburg

© 2022 ugo rondinone, pat steir, the author,
photographer, galerie eva presenhuber,
lévy gorvy publication and dr. cantz'sche
verlagsgesellschaft mbh & co. kg, berlin

distribution & marketing
dcv
sales@dcv-books.com

isbn 978-3-96912-075-0
printed in germany

published by dcv
www.dcv-books.com

DCV

acknowledgments

galerie eva presenhuber
eva presenhuber
andreas grimm
jill mclennon
christian schmidt
naomi chassé
uwe lewitzky
nicolas müller
simon schaufelberger
veronika weberbauer

lévy gorvy
brett gorvy
dominique levy
emil gombos
hunter umbel
leon yugrakh
cari brentegani
marta de mollevan
ilana wolfson

pat steir
shaun acton
alexis myre
joost elffers
ugo rondinone

studio rondinone
mattias herold
stuart mitchell
julia lee
francisco ramirez barrera
matthew broussard
matt nelson
brendan mulcahy
jerry blackman
matteo callegari
thomas d'enfert
richard mcdonough
dario gatto
pete wilkowski
julio perez
emmanuel perez
olivia van kuiken